TRUCKS IN THE 1980s

The Photos of David Wakefield

TRUCKS IN THE 1980s

The Photos of David Wakefield

Nick Ireland

Old Pond
PUBLISHING

First published 2015

Copyright © Nick Ireland 2015

Published by
5M Publishing Ltd,
Benchmark House,
8 Smithy Wood Drive,
Sheffield, S35 1QN, UK
Tel: +44 (0) 1234 81 81 80
www.5mpublishing.com

A Catalogue record for this book is available from the British Library

ISBN 978-1-910456-04-0

Book layout by Servis Filmsetting Ltd, Stockport, Cheshire
Printed by Berforts
Photos by David Wakefield

Contents

About the Author

Born in 1968, I was first taken around England at the age of six in a Scania 111 by a neighbour and this gave me my love of trucks. A truck driving career was all I ever aspired to and as soon as my careers officer at school told me the only qualifications I needed apart from a HGV licence was a good basic education, I knew what my future would be and settled into school not worrying about how well I would do. However, as I dreamed of doing international trucking, I took private German lessons as I learned it was a widely understood language across Europe. After a spell working on fishing boats and a short time in construction whilst waiting for my 21st birthday when I could take my HGV test, I started my own light haulage business with a Renault Traffic van and ran this for four years until the opportunity to take my HGV test and go and work in my father-in-law's haulage company arose. Driving a rigid Volvo F6 unfortunately only lasted a year and I moved to another local company to do international work in a 'proper truck' with Felgate Services. It was here I truly learned what European work of that time was really like, and it seemed I was never at home. Next I joined the huge Dutch firm, Frans Maas, and drove trucks on the Toyota contract they held, providing the production line in Derby with exactly timed delivery of parts from all over Europe. After four years on the road I moved into the traffic office, and four years later had become transport manager. In 2006 we were made redundant when the company was taken over and I went back to truck driving, this time for Rock and Roll trucking companies Transam Trucking, Redburn Transfer and Edwin Shirley. I also started driving for the Mclaren Formula 1 racing team and I still enjoy all of these jobs today.

Acknowledgements

I would like to thank my wife Wendy for putting up with me while I compiled this book, and the following people for providing information on pictures and the encouragement and support in completing it: Simon Waspe, Mat Ireland, Ashley Coghill, Rob Campbell, Jim Tomaszewski, John Davies, Stewart Haggerty, Peter Sumpter, Darren Blakesley, Kevin Taylor, Paul Rowlands, John Fairweather, Ben Sheldrake, Peter Harding, Lawrence Baldock and Daren Farrow. Thanks also to Patrick Dyer for the inspiration to do this. Finally, thanks to David Wakefield, firstly for standing for hours on end in all kinds of weather photographing trucks, but mostly for letting me rummage through the thousands of photos he has.

Foreword

After riding in my dad's AEC Mercury aged four in 1975, all I wanted to do was to drive a lorry. As I grew older that evolved into operating my own trucks and I'm pleased I achieved those ambitions.

When Nick Ireland told me he had met David Wakefield when they both drove for Transam/EST and they intended to create this book I encouraged them to do it. These photographs are too precious to be just left in a cupboard.

The 1980's were a special time for me. I still viewed road haulage with a childlike naivety. Russell Davies, Paul Magnus and Brain Haulage were my three favourite fleets, and they all feature here. Sadly, as an adult I have experienced at first-hand what can happen behind the scenes of running a fleet of vehicles. Transport management still fascinates me. It is much more than a vehicle going from A to B; what an onlooker sees is the tip of an iceberg.

I am so pleased David took the time and made an effort to take all these photographs. Equally Nick should be commended for the work in creating this book. He asked me for some help with information for some of the captions and I was very touched to be asked to write this foreword.

Life will continue to change and to survive we must adapt. People need to remember that trucks are essential for modern day life. We can't live in the past, but to forget it is a mistake.

Well done and keep on trucking!

Simon Waspe, respected author,
haulier and ADR & DCPC instructor
February 2015

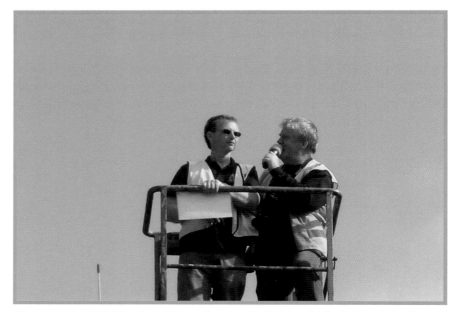

Simon surveys his kingdom! From the top of a 'Cherry Picker' Simon (left) and a radio interviewer look out over the Orwell Crossing Truckstop at the 2013 Gathering Of The Griffin Show which he helps to organise.

Preface

Since my teens I have been photographing trucks and thought that I had amassed a large amount. That was until I saw David Wakefield's collection! Where I sporadically took photographs of trucks that I was interested in, David took pictures of most things he saw, and as a result has the most comprehensive history of road haulage in the 1980s that I and other people have ever seen. Many of the haulage firms he snapped have disappeared for ever, and certainly most of the truck makes are only seen in history books now. David has captured pictures of trucks from a time when many would argue the job of truck driver was better than nowadays — no mobile phones, receiving backloads from fax machines at your unloading point or roadside pay phones, less traffic on the road, CB radio was all the rage, truck customising was with stickers, cab flags, Michelin men and anything Americana not just bolting a spotlight bar on — and most certainly the balance between UK hauliers on the road and ones from Eastern Europe has totally reversed from then. Borders between countries meant stopping and completing customs formalities much of the time after spending hours in a queue merely to get to the border itself. When David told me he had thousands of photos packed away in a cupboard, I knew that they needed to be out there in the world for everyone to see, so persuaded him to let me publish them in a book. They have jogged my memory in so many ways and I hope they do the same for the reader. I have tried to include as many different truck makes as possible to remind people just how many different options there were in the 1980s for hauliers. I have also tried to include as many familiar companies from that time in the hope that most people will find a connection or two, even if it's just to remind them of a firm they had forgotten about. I have tried to add information to the pictures based on my own knowledge and that of other people, many of whom have enthusiastically provided much more than I needed, but I am eternally grateful nonetheless.

Introduction

David Wakefield was born in Eastry, Kent in 1964 and, as a child, used to go on family walks along the cliff tops of Dover overlooking the Docks. He often watched the trucks going through the port, imagining where they would be going to and coming from. This was the start of his love of trucks.

In the late 1970s he started taking photos of the trucks and became a regular fixture during the 80s at the bottom of Jubilee Way, taking photos of the trucks going in and out of the port.

After leaving school at 16 and working for a car repairer, he saved up the money to take a class 1 HGV course.

At 21 he got his first truck driving job with Kent Salads. His first truck was a Volvo F10, followed by a brand new Scania 112.

David has had a varied driving career over the last 30 years, driving throughout western and eastern Europe, and also North Africa. He has worked for various companies such as Traction GB, David Croome, Russanglia, Kepstowe, Fleetwood Transport and, currently, Edwin Shirley Trucking, working for the music and entertainment industry.

He spent many years driving throughout Russia, Kazakhstan, Uzbekistan and many other former Soviet states. He once even loaded by the Kazak/Chinese Border. He often drove on poor roads, desert roads and non-existent dirt tracks at the same time as battling with the Russian winter.

Many of David's truck photos have appeared in other books, such as *Highway Heavy Metal* by Arthur Ingram and Martin Phippard and Patrick W. Dyer's *At Work* series of truck books.

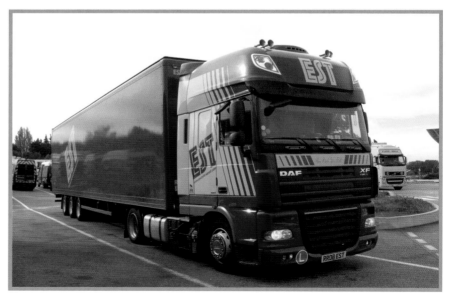

David's truck whilst at Kent Salads.

David's current truck with E.S.T., pictured in France while on the Bruno Mars Tour in 2014.

1

Tractor Units

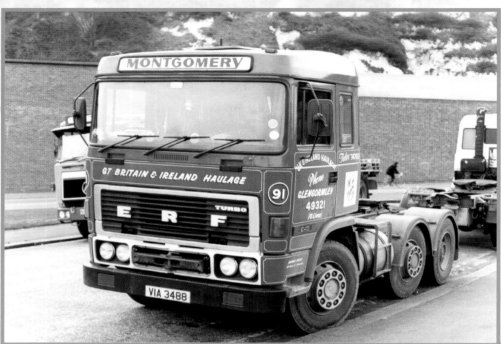

1.1 *A ERF C Series twin steer unit of Montgomery at rest in Dover, accompanied by a Seddon Atkinson and an Iveco.*

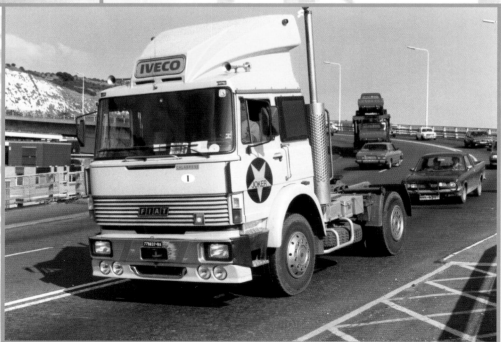

1.2 *There is so much to look at in this picture, from the Italian Iveco Special, to the Marina pick-up behind that is the lead in a procession of classics – Vauxhall Cavalier, Alfa Romeo, Mini Clubman, Triumph Dolomite and, lastly, a Citroen 2CV. Notice also the brand new Peugeot pick-ups being imported into the country on the transporter.*

1.3 *A handsome Volvo F12 6X2 unit, possibly an owner driver. David had photographed this before with a flat-bed trailer with steel coils on board so perhaps that was its usual work.*

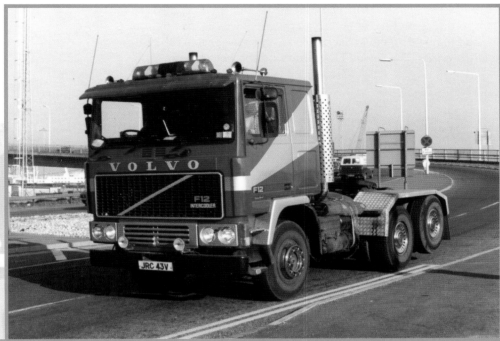

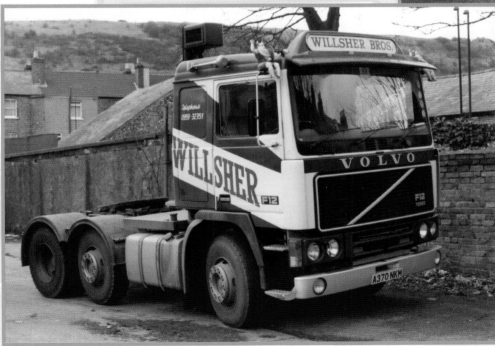

1.4 *A tidy Willsher Bros., Volvo F12, twin steer unit. An additional 'saddle' tank has been fitted across the chassis for extra mileage between fills.*

1.5 *Since 1849, and with its first office in London in 1910, LEP Transport were involved in air and sea freight as well as road transport, and had some 50 offices in the UK alone, and nowadays are known as Agility Logistics. This Volvo F12 was based at the Dover depot.*

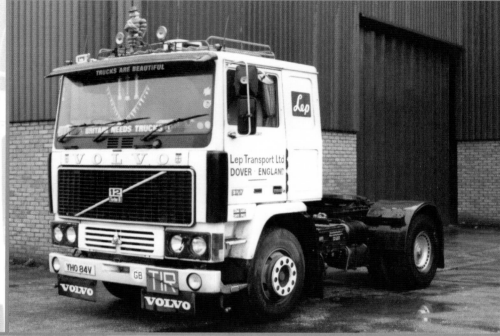

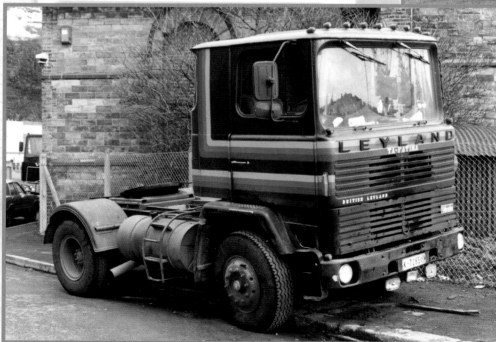

1.6 *A regular visitor from Malta was this Leyland Marathon decorated with roof marker lights and Scania style stripes on the side of the cab.*

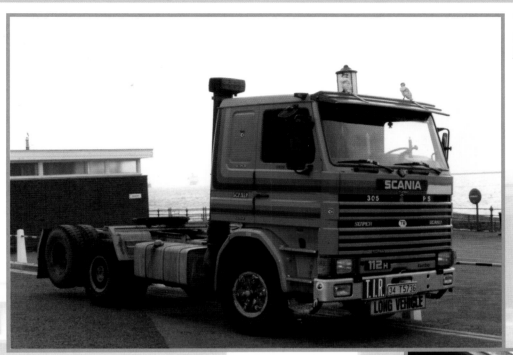

1.7 *A heavy duty looking Turkish Scania. This Istanbul registered R112H 6X2 is resting at Dover and sports Trilex style wheels on the front axle.*

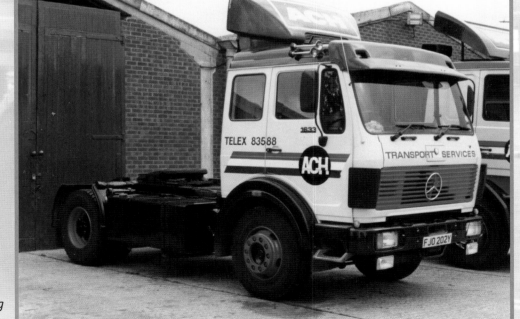

1.8 *A visit to the Aylesbury depot of Aston Clinton Haulage enabled David to photograph most of the fleet that was there on the day. Amongst the Volvo and Scania units he also found some smart looking Mercedes 1633 tractors.*

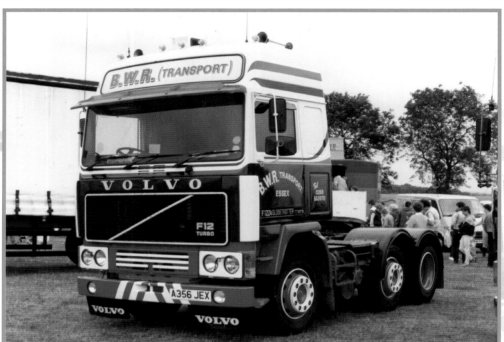

1.9 *An attractive F12 of B.W.R Transport of Essex. Ex G.L. Baker driver, Brian Rogers, ran around eight trucks from the Coward Industrial Estate in Chadwell St. Mary and had a couple of trucks in Interbrit colours.*

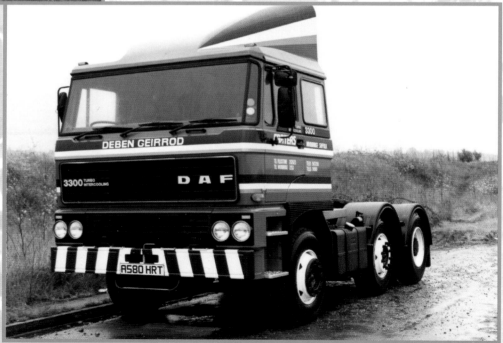

1.10 *Carters of Woodbridge, Suffolk bought six DAF 3300 tractor units numbered A580–585 HRT. They were bought from Ben Cooper, a DAF franchise in Norwich Road, Claydon. All the trucks had a name on the front with the prefix Deben; this was after the River Deben. The second part was named after warrior themes and latterly mythological characters.*

1.11 *A very smart P.C. Howard ERF C Series being shown off at the Newark showground. In 1939 Percival Charles Howard purchased his first lorry and diversified from farming into haulage. In 1966 the main source of work was from 'London Brick' and later British Steel at Corby. Howard's was a founding member of Palletways, and now has depots at Peterborough, Northampton, Corby and Swindon.*

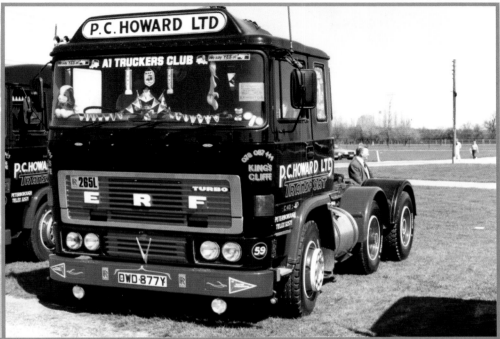

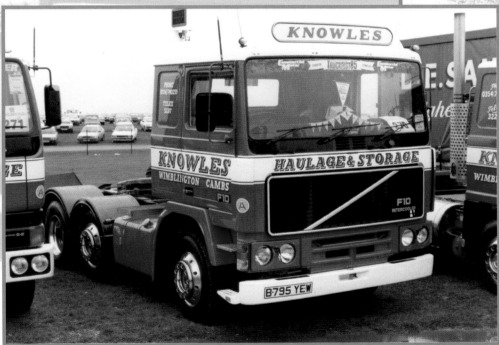

1.12 *Pristine Volvo F10 from the then very mixed fleet of Knowles. Today Knowles runs a predominantly Volvo fleet from its large site in the heart of the village of Wimblington, Cambridgeshire, where it offers warehousing and distribution services, and also has a number of trucks on container work.*

1.13 *Febland Europa stopped trading in 1986, but the Febland Group of companies is still in business and is a successful importer and retailer of Italian furniture. The company had a base in Novara in Italy as well as Folkestone and the head office in Blackpool.*

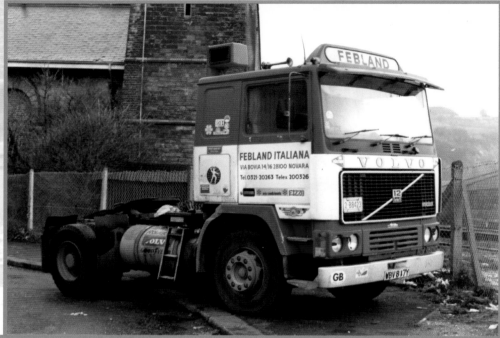

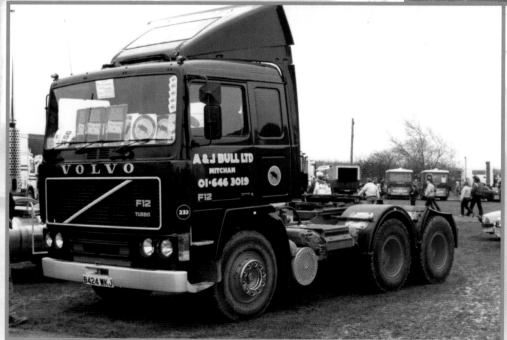

1.14 *South London firm A & J Bull used to have a very large operation involved in the transport and disposal of waste products, from skip lorries to articulated refuse trailers. Today, trucks with a similar livery can be seen but with the name Taurus on them, a reference to the once mighty name of Bull. Belgian owned United Waste bought Bull's out in 1998 and continued to run it alongside its existing UK waste company Lancashire Waste Services.*

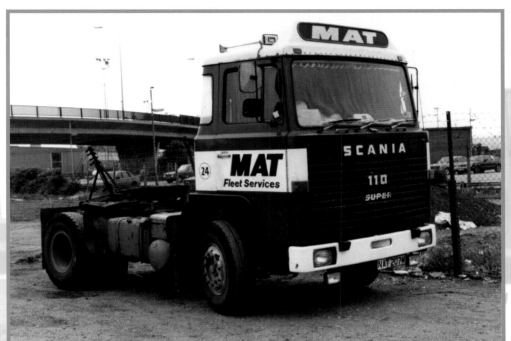

1.15 *Founded by Arnold Kunzler in Switzerland M.A.T grew to be a major force in International freight forwarding. MATDAMAR (MAT Distribution And Maintanence And Repair) was set up to run the trucks and perform the maintenance function within MAT Transport. The name was changed in the mid-1970s to MAT Fleet Services. Presumably, this day cab had an occasional bunk fitted as it is furnished with curtains.*

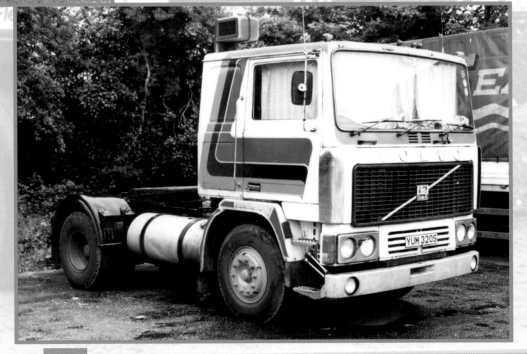

1.16 *A Volvo F12 from the U.F.O. fleet. Dewsbury based Universal Freight Organisation had as a slogan on their trailers – Transport Of The Future – and used to specialise in transport to Italy and Spain.*

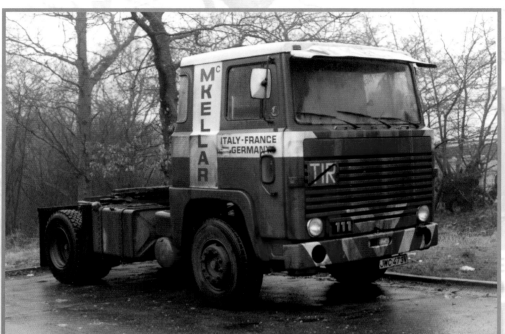

1.17 *Looking in desperate need of a wash is this McKellar Scania 111. David reports that this unit belonging to the well-known Purfleet company was towed in to the services where he spotted it, which would explain the grime covering the front, especially if it had been towed in from Europe.*

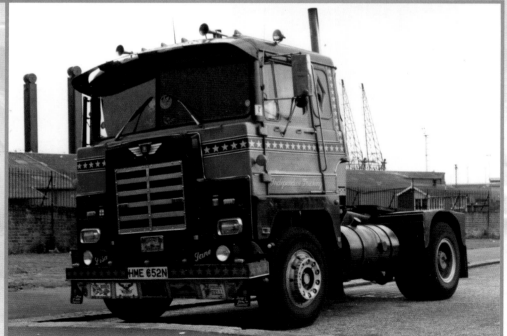

1.18 *Formerly in the yellow livery of Ollins Overland and used on the Middle East run, this Scammell's ownership then passed to Dennis Anderson. The Crusader has had a custom grill fitted, West Coast mirrors and a neat diamond shaped sleeper window.*

1.19 *Henry Smither & Son, taken over by P&O Road Services in 1968 to operate container services, was at one time all ERF. In 1973 Smithers took delivery of its hundredth ERF A Series and had yards at Southampton and Orsett in Essex.*

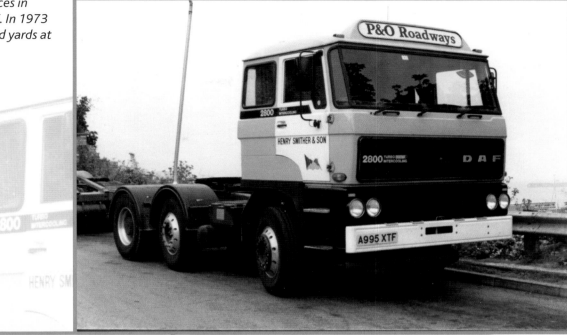

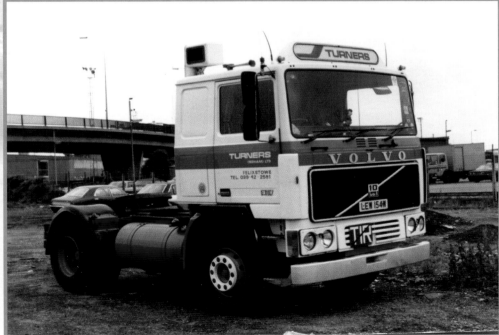

1.20 *In 1930, brothers Wallace and Frank Turner bought their first vehicle and began delivering loads from their father's farm in Soham, Cambridgeshire. Eighty years on and Turners of Soham have become one of the UK's biggest haulage companies, with services such as storage and warehousing, container and tanker haulage and cold store operations.*

1.21 *Proudly displaying the fact it is an owner drivers' truck, this Mercedes 1628 is bristling with the extras of the time including a rather nice pair of exhaust stacks. Handy to know also if you ever needed to contact the driver you could go onto channel 19 and call up 'Skinhead'.*

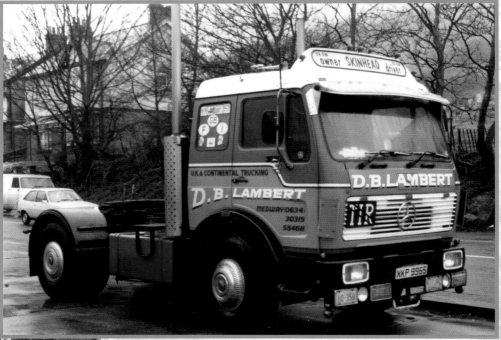

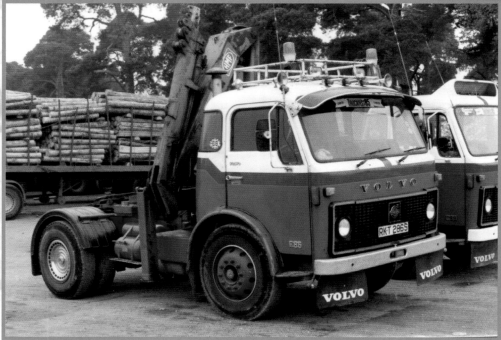

1.22 *Seen in the yard of timber haulier Ken Peckham in Norfolk is this lovely little Volvo F86. Mr Peckham, as he was known, had a mixed fleet of Volvo and Scania, including one prizewinning 142 formerly belonging to Dave Miller which had been featured in trucking magazines in 1986. Fitted with a HMF crane it sits next to the company's other F86 of the time.*

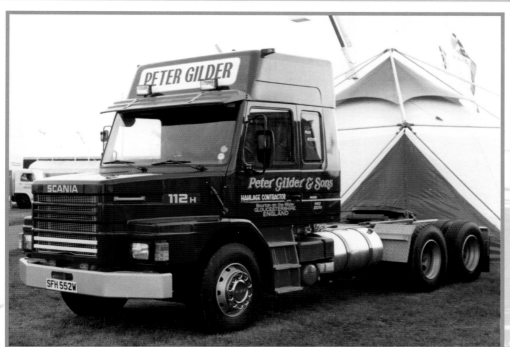

1.23 Peter Gilder was a livestock haulier from Bourton on the Water, Gloucestershire and he used to import trucks, mainly from Holland, to use in his transport fleet and to sell. This lovely Scania T112H has an Estepe high roof conversion fitted. Interestingly the truck started life in Germany as a normal cab tractor unit which Peter bought from his old friend, Pym De Vriss.

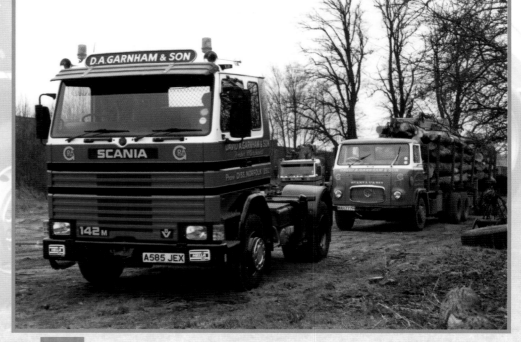

1.24 David visited the yard of D.A. Garnham in Diss to see his latest editions to the company – the pair of Scania 142M units. Parked behind is a gorgeous 1966 Scania Vabis LB76 fitted with the DS11 turbocharged engine that David Garnham planned to run for at least another 10–15 years. The two 142Ms replaced a 141 and a 140.

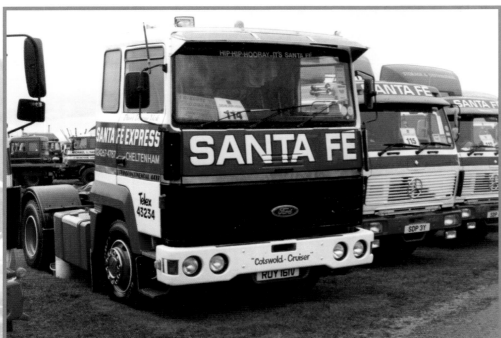

1.25 *Santa Fé of Cheltenham ran a fleet of mixed trucks in its striking livery. Apart from six Ford Transcontinentals, the rest of the fleet was either Scania or Volvo. Named after a railroad in the U.S.A. the company was founded in 1971 and in 1982 was bought by the Oldacre group which included Oldacre Services, a Mercedes dealership. Wincanton subsequently bought the company in the 1990s.*

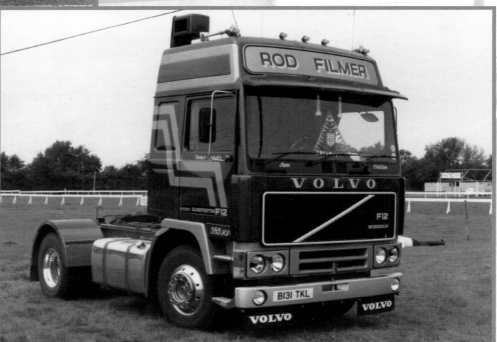

1.26 *Rod Filmer, an owner operator for over 30 years, had this early F12 Globetrotter when they were first released. Fitted with the kitchen pack, it's seen here when new.*

1.27 A Fiat 190.38 of Italian firm Merzario, seen in Dover. Merzario specialised in intermodal freight, using the 'kangaroo' type trailers that could be shipped by train. Brain Haulage and Felgate were sub-contractors for them in the UK, amongst others. In later years, Merzario used tilt bodies that could be carried by skeletal trailers, and could be dropped at railheads, taking advantage of the then new 44 tonne limit for intermodal traffic. The disadvantage of these was that the body sat that much higher on a UK skeletal, and it made for an awkward job to undo the tilt to load, as this author can testify.

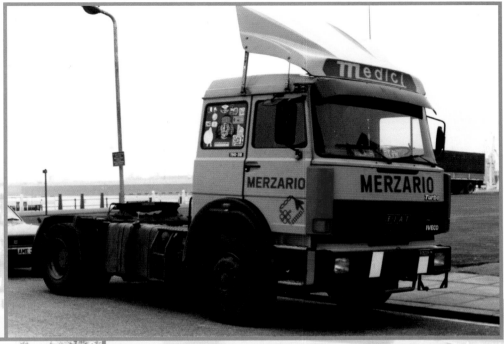

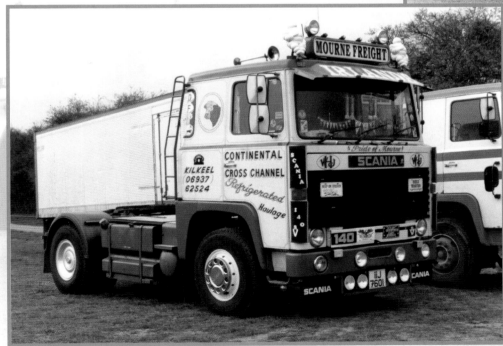

1.28 The 'Pride of Mourne,' and so it should be. This Scania 140 of Mourne Freight from Kilkeel has an unusually shaped fuel tank and pulled a fridge trailer on international work.

2
Container Trucks

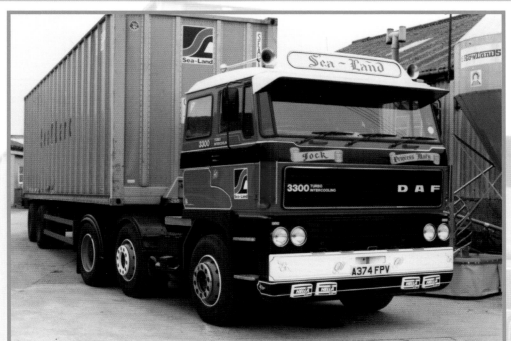

2.1 *Loadwell owned this lovely looking DAF 3300 in Seawheel livery. Terry Ingram thought so highly of his driver George 'Jock' Wardlaw that he had his nickname sign written on the front along with 'Princess Mary', Mary being the name of Jock's wife. Jock had previously driven for EW List from Debenham who sub-contracted to Bob Carter of Trans UK fame. When List finished business, Bob offered Jock a job at Trans UK, something many drivers would have jumped at, but Jock wouldn't join Bob and ended up at Loadwell, where he stayed until he retired, finishing his driving career at the wheel of a Scania 143.*

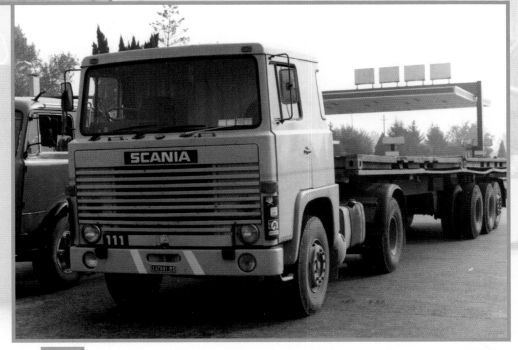

2.2 *Seen at a service area near Venice, this Italian Scania 111 with a skeletal trailer with self rear steering, is carrying two 20ft flat rack containers on board. Typical for trucks of this age is the right hand drive layout.*

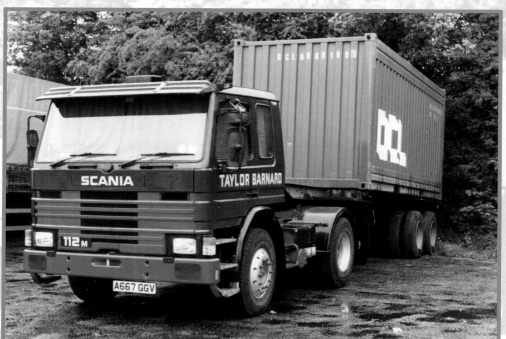

2.3 In 1959 Jack Barnard was asked if he knew where 12000 tons of Cuban sugar could be stored in 2.5cwt bags. Against family advice he bought an old hanger on Mendlesham airfield and literally manhandled it in. In 1962 Jack bought H.G.Taylor Haulage of Clacton, Essex, which started the transport business. In 1964 Anglia Warehousing Co. was launched to operate a distribution arm. A five acre site was acquired at Felixstowe in 1969 with two large warehouses built to store paper from Finland. The company was renamed Taylor Barnard in 1976, and a nationwide depot network followed. Taylor Barnard was bought out by TNT in 2000, and on 21 September, 2001 the container division was shut down with only a weeks' notice given. At the CEVA yard in Mendlesham, Suffolk you can still see some yard shunters still in the Taylor Barnard livery today.

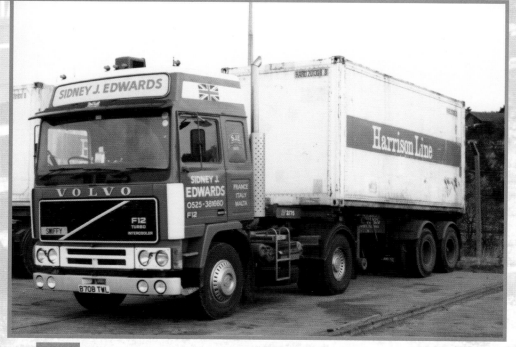

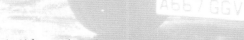

2.4 Sidney Edwards was an ex-Dawsonfreight driver and in 1972 set up his own haulage company doing UK and European work from a Leighton Buzzard base. Malta was a regular destination and here is a very nice Volvo F12 Globetrotter of his, pulling a 20ft skeletal trailer with a Harrison Line box.

2.5 Owner driver John Elsdon had PME 750X after running a succession of Scanias. Son Kenny was a paint sprayer working for Les Sampson Transport and he painted John's Volvo for him, choosing the black colour. When Kenny started as an owner driver he ran his truck in the same livery as his father, and when John retired, Kenny started Elstran, the highly attractive trucks being instantly recognisable. Kenny is also well known for his passion of restoring period trucks, and at one time was regularly taking two Scania 1 series units in Brain Haulage livery, a Bedford TK rigid and a Scania 143 tractor in Elstran colours to shows.

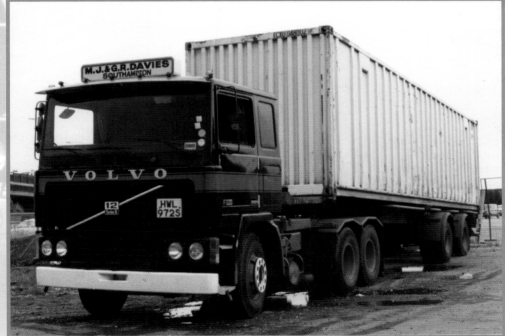

2.6 HWL 972S was bought by John Davies second hand in approximately 1982. It was an ex-Cave Wood transport LHD unit and John was using it originally pulling SCAC trailers out of Portsmouth docks for a company called RH&D. In 1983, when the weights in the UK went up to 38 tons there were not that many 6-wheeled units about, and RH&D offered an interest free loan to any haulier prepared to convert existing units to tri axle set up, of £2000 per unit. This seemed a good idea for continuity of work as all the French trailers were coming over with 23 tons on board. Having accepted their offer of finance, HWL 972S & SJL 972S, a Volvo F89 they also ran, were sent to Hartshorne Motors in Birmingham for rear lift conversion by means of a Granning lift axle. The main driver of HWL was Ian Hall who kept the F12 in immaculate condition. As time progressed, John bought trucks with pre-converted Granning axles, which included an F10 and an F88.290. Eventually he bought newer models and then progressed to buying new trucks, mainly Volvo but nowadays exclusively Scania. Founded in 1971, John's fleet is instantly recognisable on the road today as it operates across Europe from the base in Fareham, Hampshire, and the trailers carry on the back doors the slogan 'SuperCalibreFrigoLogisticsExportImportDavies'!

2.7 Goodway was formed by two ex-Russell Davies managers in May 1981, Roger Jennings and Peter Miller, when they bought the assets of Contship's UK haulage arm – six Scania 111s and skeletal trailers. Harvey Macintyre left Russell Davies and joined the other two as third director in September 1981. Goodway and a container line from Israel, Zim, formed joint venture Sabra Container Services in January 1987, exporting sugar in 20ft boxes using three Volvo FL10 units, registrations E180 NME, E181 NME and E182 NME, supplied by Rydale of Chingford. Bought by Hanbury Davies in November 1999, Goodway had 120 vehicles with bases at West Thurrock, Kirk Smeeton (Leeds), Manchester and Felixstowe. Harvey is known nowadays for his Macintyre fleet of trucks operating from Felixstowe, Southampton, Bristol, Ipswich, Selby and Liverpool depots.

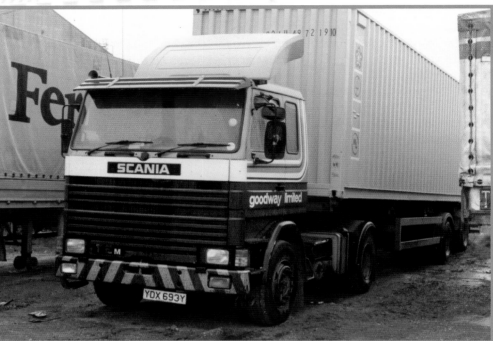

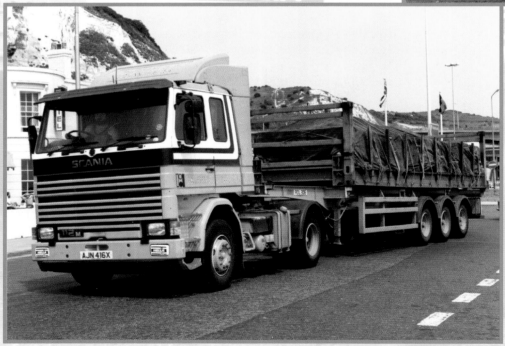

2.8 AJN 416X was one of 10 new 4X2 Scania R112 units that Russell Davies bought and based at Barking when Felgate Services was purchased. Originally they were a revised livery of two tone blue and white with the R.D. corporate stripes, but this truck along with seven others were later repainted in the more traditional colour scheme. Nine of the trucks were converted to 6X2 tag axle layout, the only one left as a 4X2 was AJN 417X.

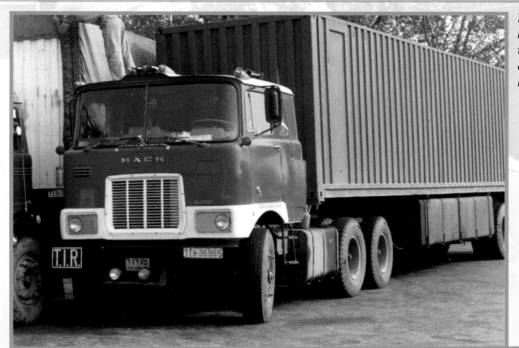

2.9 An Iranian Mack F700 registered in Tehran rests at a service area near Brescia, Italy. Note how it is being used as a platform to repair the tilt trailer next to it. Also interesting are the twin fuel tanks on the chassis of the trailer, essential for the ultra long journey from Iran to Europe.

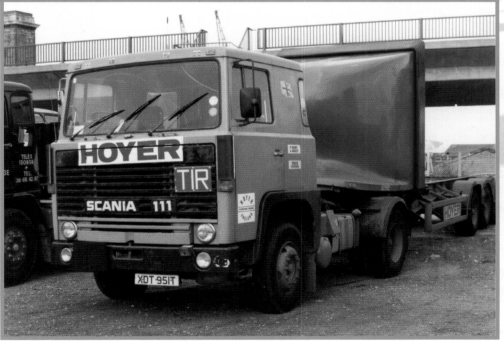

2.10 Tank containers are not renowned for their aerodynamic profiles and the fairing fixed to the front of this 20ft skeletal trailer is an effort to reduce the wind resistance drag. The Hoyer Scania 111 pulling it features a T.I.R. plate and several countries' flag stickers which suggests it did European trips, although the tiny fuel tank would have meant frequent stops to fill up.

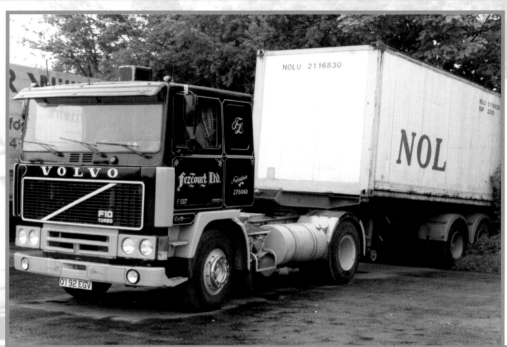

2.11 *This Volvo F10 in Gate Services on the A2 is in the attractive livery of Fezcourt, from Felixstowe. Presumably it was a European import as it was left hand drive and had a 'Q' registration. There was also a F88 in the same livery also pulling containers.*

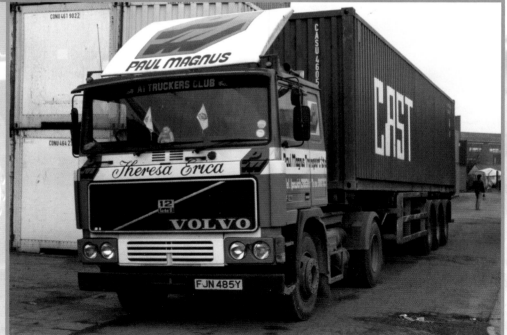

2.12 *Paul Magnus started in 1973 as loading brokers. In 1980 all the activities became known as the Paul Magnus Group, trading from a six acre site at Parkside, Duke Street, Ipswich. The group had seven departments – ships agency, haulage, warehousing, container storage and repair, international removals, cargo superintending and marine insurances. In 1978 diversification began into warehousing, transport and repairs of containers. Paul rented five Scania 111s, initially off Russell Davies, BRT 593T in red, white and black, three in green and white DPV 584T, DPV 585T and JRT 600V. DPV 583T was painted in the blue, white and red livery of Municort. After that Paul bought his own trucks, originally named after staff members' daughters. In March 1988 he sold the business to Peter De Savary's group, Highland Participants, but started up again in 1994 with three Volvo FL10 units.*

2.13 *Harwich Transport was set up to handle the DFDS traffic through the town port, with John Stroud as managing director. As the UK gross weight limit was 32500kg back then, they needed a light weight unit for unloading Danish sugar containers and this is where BAH 754Y came in. Fitted with blower equipment and a tipping skeletal trailer it regularly delivered to Trebor Sweets at Colchester, Mars at Slough and Chivers Jam at Histon, Cambridge.*

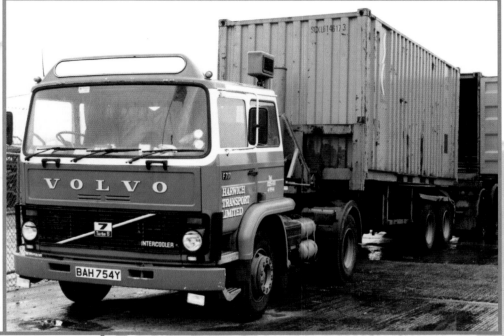

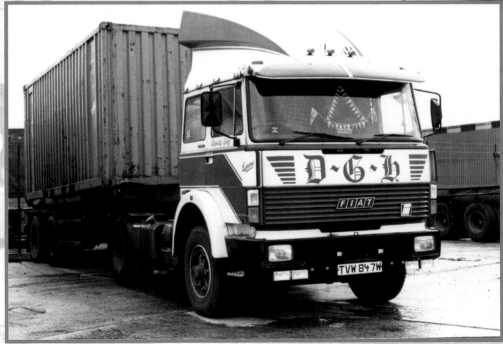

2.14 *Set up in 1974 to co-ordinate the ideas and technical advances of Fiat, Magirus Deutz, Unic and Lancia, the Industrial Vehicles Corp is also known as IVECO. Although not a marque in its own right at the time, the IVECO name was carried by all new models, but included the name of the old manufacturing plant of the engine, although the cab could be a partner's design.*

2.15 *James Kemball was started in 1973 by Charles Reed with three Mercedes Benz units. The yard was originally in Sub Station Road, Felixstowe, and then moved to Byron Avenue and Dooley Road before relocating to the current base of Hodgkinson Road. RGV 373R, a 1625, was new from Truck Services of Ipswich, Martlesham Heath, Ipswich. K Line was Kemball's biggest customer with many trucks being painted in their livery, but others were also in the black livery of Medite. Charles sold the company to K Line in February 2004. He stayed on until the November of that year to help with the transition, and then retired.*

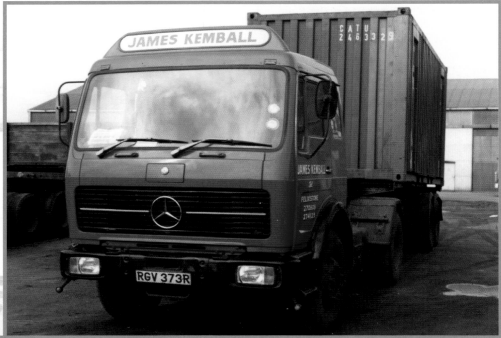

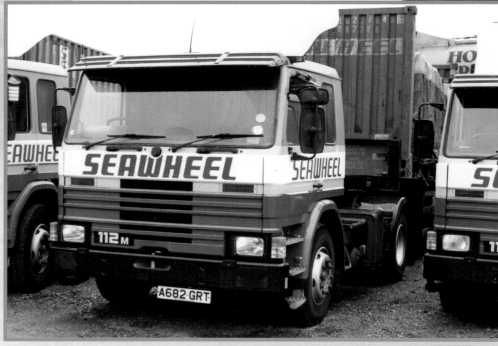

2.16 *Scania P112M, A682 GRT in Seawheel livery, owned by George Cooper of Manningtree, Essex. Seen here at Cooper's yard, it is loaded for the next day with a flat rack container on.*

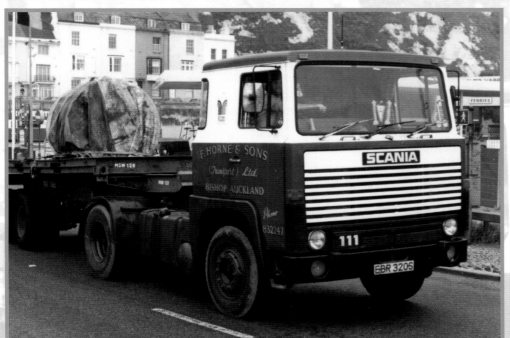

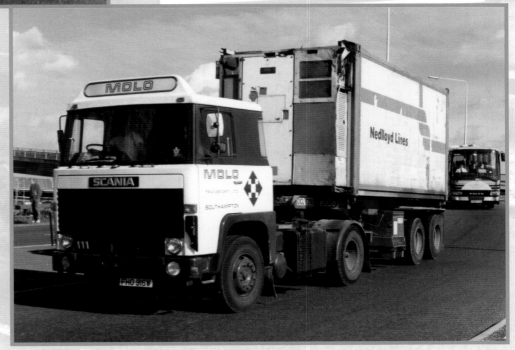

2.17 *This Scania 111 will be pulling hard as it starts the climb up Jubilee Way, Dover, as it's dragging a steel coil behind it on a flat rack container.*

2.18 *Molo Transport of London also had a base at Southampton where this Scania 111 hails from. Of interest is the large box on the side of the skeletal trailer chassis which I can only assume is a generator box for the rather beaten up reefer container. Nowadays, 'gen sets' are attached only when needed by the container companies, and fit neatly onto the front pins of a 'skelly' or bolt directly to the front of the container.*

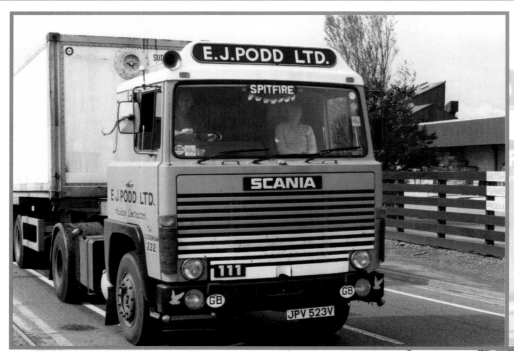

2.19 *Eddie Podd, based at Coddenham, handed his business over to his son Roger who ran day cab Scania 111 YGF 367S that was ex-Dallis Heavy Haulage, and was a dock shunter. Additionally, JPV 523V was used pulling Hapag Lloyd containers for DCD with driver Bernie Swan who served at Podd's for 18 years. DCD (Deutscher Container Dienst, which in English equates to German Container Services) were formed in 1973 and were the UK agents for Hapag Lloyd. Eddie ran the Old Bell Pub in Crowfield, which was the original venue for the now infamous Crowfield Truck Rally, now held at Ipswich.*

2.20 *Seen here sub-contracting to Ralph Morton, AOO 199L was an ex-RAR of Ipswich LHD F89 330bhp 4X2, with a coach differential and reportedly would 'fly'! RAR sold it and five years later bought it back. Based in Ipswich, Rodney Albert Robinson was engaged in national haulage although his trucks were all left hand drive and fully specced for international trips. His original yard was at The Drift, Ipswich and he had a green F88 in Roto Line colours and pulled their tilt trailers with it. When Roto went bust he was owed thousands and never recovered and closed down in the early 1990s. In 1995 Rodney started up again as an owner driver with a 6X2 Volvo F10 C225 JWJ, pulling containers for Roadways. RAR colours were a tasteful two tone brown – Rover Brazilia and Tobacco Leaf.*

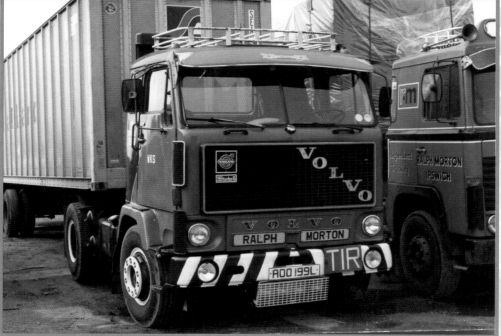

2.21 NRT 899W was new to P&O Roadways before John Goodwin of Bury St Edmonds bought it, and was built as a 4X2. John had it converted to a 6X2 tag axle by J.R. Engineering at Rougham, Suffolk at a cost of £2750. Starting in 1973 as an owner driver, John pulled Sealand containers with an ex-Fradden and Osborne of Cornwall ERF LV, MCV 163F. After being on the road only six weeks, the ERF dropped a valve – many other owner drivers would have given up then, but John was a mechanic and he loved working on trucks! John still owns a yard on Rougham airfield which is rented to Matthews of Great Yarmouth. He had a smaller depot also in Sub Station Road in Felixstowe, and sold the 36 truck company on 6 January, 1997 to WHL Group of Stratford's subsidiary Transport UK. WHL were agents for Choyang Container Line and wanted John's trucks for that work. When Choyang went bust, Transport UK followed in July 2002. Goodwin trucks all carried girls names of friends and family of John and this one bears the name Jane.

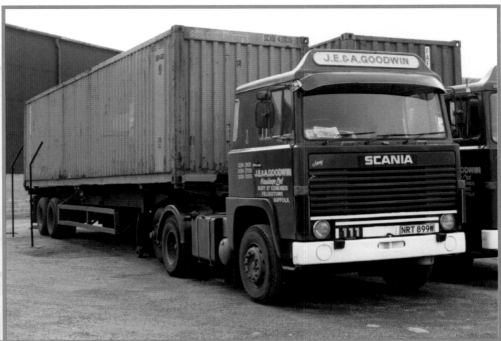

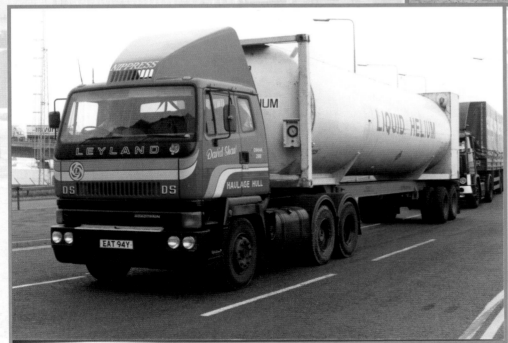

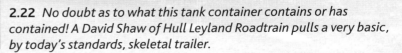

2.22 No doubt as to what this tank container contains or has contained! A David Shaw of Hull Leyland Roadtrain pulls a very basic, by today's standards, skeletal trailer.

2.23 *Roy's Rig – well Roger Turner's actually! Turners were from Fordham, Ely, Cambridgeshire, and Roger had a lorry with his farm which increased gradually to four, at which point Roger decided to set up a separate entity as R. Turner Haulage in 1982. Over the years, Ro-Ro trailers from the docks have been their regular work and their current fleet stands at 53 trucks. Roy Fox's F1220 had a replacement grill fitted at some point that came from a Volvo F10.*

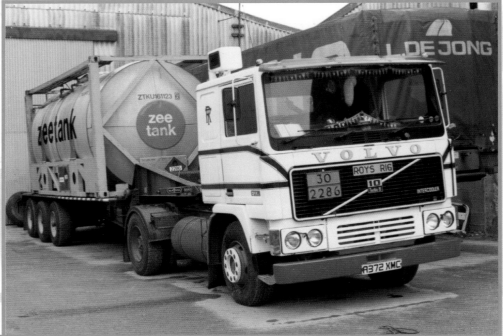

2.24 *Rotahaul was owned by Alfred Manchester and his sons, and was based in East London. They had MVX 520V from brand new, but as it drops down into Dover with a tank container with Ethanol markings on it, it looks a little weary, and was later repainted in white. Note the front exhaust for tank work.*

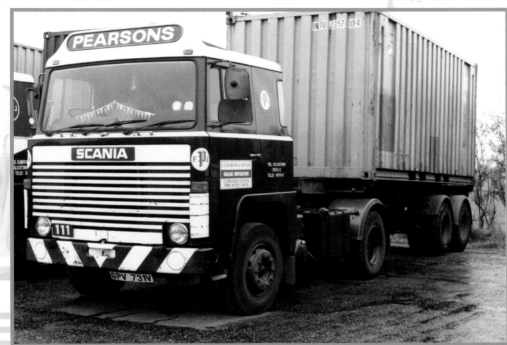

2.25 F.J. Pearson & Son were originally agricultural hauliers, principally moving livestock and some seasonal sugar beet, but as the work dried up, Frank Pearson turned to container haulage. In the early 90s there was a global downturn and the company was sold to Ted Seaman of Cartco in February 1990.

2.26 When Charlie Brain started out in haulage, his company was named J. & C. Brain, after his children John and Carol. The name was eventually changed to Brain Haulage but in 1982 the name was revived when a base in Holland was established. Carol had married a Dutchman, and a series of dock worker strikes in Holland saw the company established in order to deliver the containers via road rather than sea, and for a time the Dutch registered trucks were regular visitors to Britain. The operation in Holland had 17 trucks, eight Volvo F12s, eight DAF 3300s and one Renault 310. Interestingly all the trucks were fitted with Scania roof air deflectors.

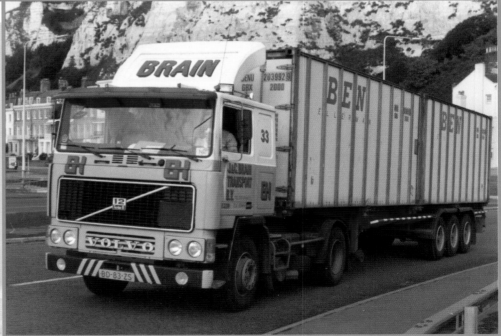

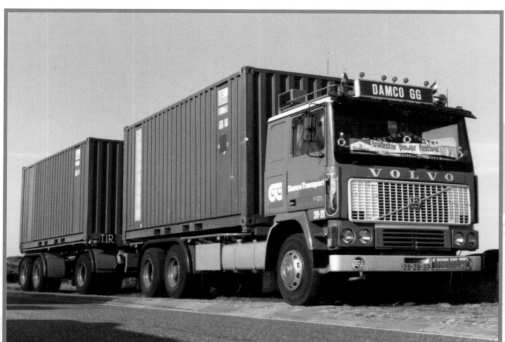

2.27 How the Dutch do it at home! This striking Volvo F1225 with A-Frame drawbar trailer and two 20ft containers was seen at the Truckstar Power Festival at Zandvoort.

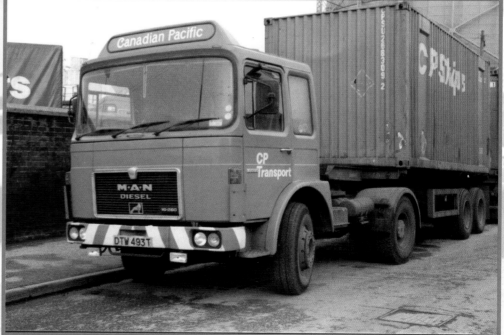

2.28 C.P. Transport was owned by the Canadian Pacific group of companies. In May 1981 it had a fleet of 20 4X2 artics that parked in George Davies' yard in Tilbury, and they worked out of berth 39 in the dock. There were 12 M.A.N. 16280s, four Scania 111s and four Volvo F7 artics. In 1982 C.P. Transport changed its name to Tracto.

2.29 *New from Scantruck at Stowmarket, JNC 100V was a celebration to mark 100 Scania trucks in the Russell Davies fleet. Based at Felixstowe on the general haulage fleet, Glyn Davies got the number plate especially for driver, John Norman Candler.*

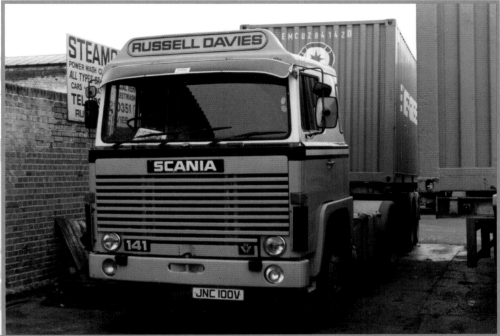

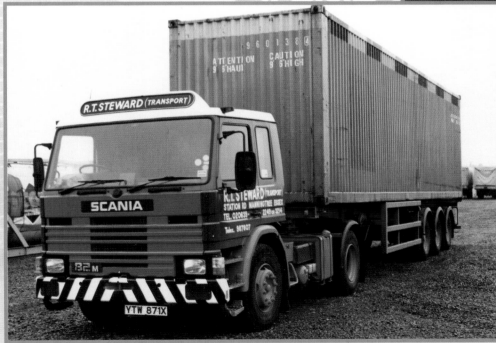

2.30 *Bob Steward started as an owner driver with a Ford D Series rigid in 1971. YTW 871X was Bob's fifteenth Scania purchase, having three other P82 units alongside this one. The trucks were all named, the prefix Weeley being his previous base before moving to Manningtree, and this one was named Weeley Monarch.*

2.31 *Loadwell was started in 1972 by partners Terry Ingram and Roy Goode, and was SeaLand's first dedicated haulier. At one point Loadwell had the largest fleet of Volvo FH12s in the UK, and many of their vehicles were painted in the livery of Seawheel. The company was bought by the rapidly expanding Hanbury Davies in January 2000. Here C460 VBJ rests, one of 17 DAF trucks with sequential number plates.*

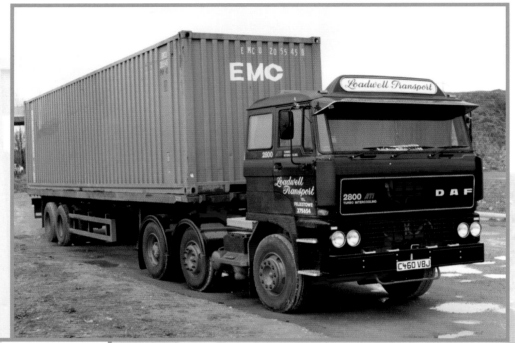

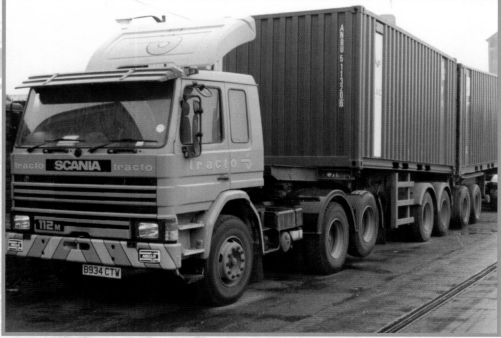

2.32 *C.P. Transport changed its name to Tracto in 1982, starting with an initial fleet of 14 C.P. Transport vehicles in Tilbury. Subsequent depots were opened at Warley, Felixstowe, Speke, Birmingham, Plymouth and Grays. In June 1994, Tracto was sold to Goodway, the keys being handed over on the 27 June as Canada Maritime, the parent company, wanted to concentrate on its core business of shipping.*

3

Flat Bodies

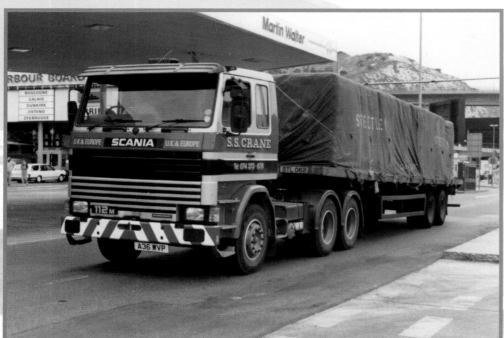

3.1 *A simple and pleasing livery on the Scania 112M of S. Crane with a sheeted load leaving Dover Docks. Note in the background the Ford Granada heavily laden down with holiday luggage!*

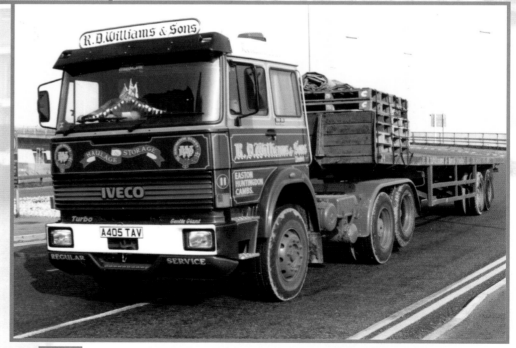

3.2 *A very traditional livery on this R.D. Williams Iveco 190.30 of Huntingdon, Cambridgeshire. Nowadays, Williams have a very large smart fleet and still operate from their Easton base alongside the A14 near Huntingdon.*

3.3 *This DAF rigid was seen at Brands Hatch racing circuit and was tasked with distributing fire extinguishers to the marshals around the track. The body appears to have been adapted specifically for this use, so one can assume it was a permanent feature there for a period of time.*

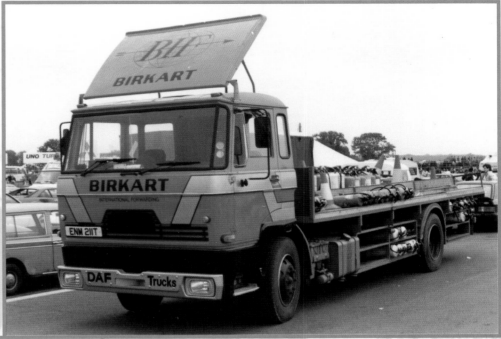

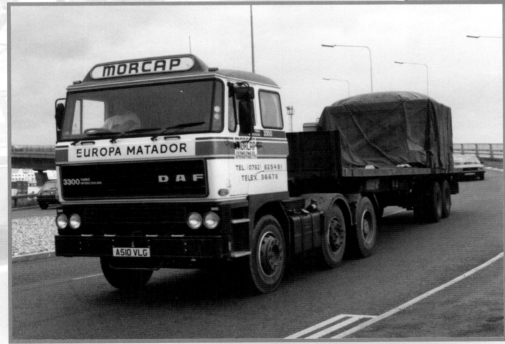

3.4 *Europa Matador from the well known Morcap fleet of Stoke on Trent. I can only hope that the load under that sheet isn't too heavy or it would have given the DAF 3300 traction problems being seated right over the trailer axles.*

3.5 *An interesting truck, a Scania 82M with single axle trailer and a lightweight HIAB crane situated in the middle of the trailer, indicating a light load is carried on this.*

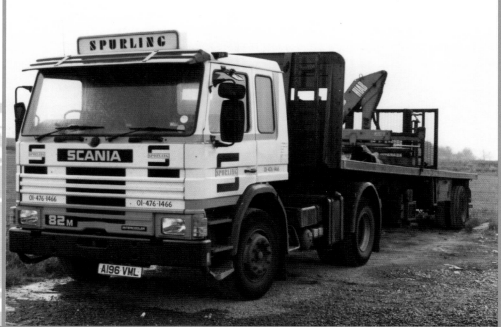

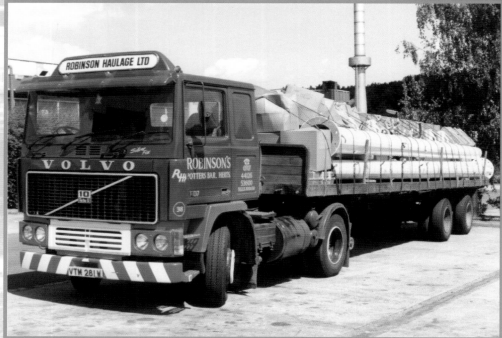

3.6 *Robinsons are well known for their fleet of flat trailers and heavy haulage outfits. They specialise in haulage for the construction and rail industries, and this F10 has a mixed load that is neatly roped on.*

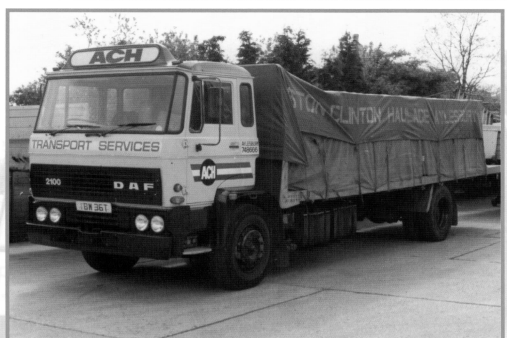

3.7 *Aston Clinton Haulage was a large international haulier that was taken over by Norbert Dentressangle. This neat DAF 2100 was taken at the yard near Aylesbury; note the twin tanks fitted. The ACH name was eventually phased out and the trucks, by then Renault Magnums, were painted in the usual ND red livery.*

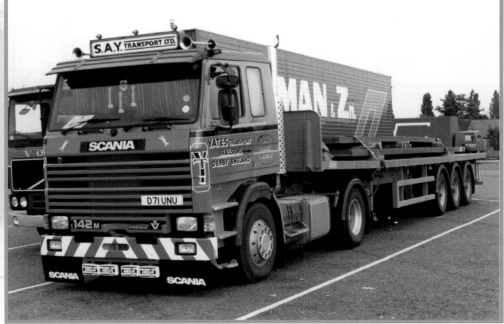

3.8 *Stuart Yates ran a very nice looking mixed fleet of high horsepower trucks from his Derbyshire yard. They carried a lot of steel and had a large amount of flat trailers for this purpose. Bewick International bought some ex-S.A.Y. Scania tractors, instantly recognisable by the personalised number plates.*

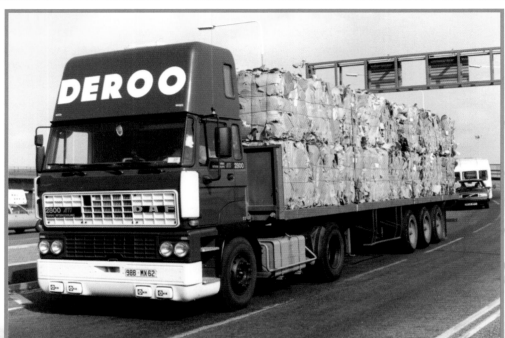

3.9 *This DAF 2800 from the fleet of French haulier Deroo has a rooftop sleeper on a day cab to enable the maximum length of trailer to be utilised. These cabs were not popular with drivers, and the sleeper pods deemed unsafe as should a fire break out in the night – the escape route from the sleeping area was precarious. Note the small number of ratchet straps securing the load of waste paper bales.*

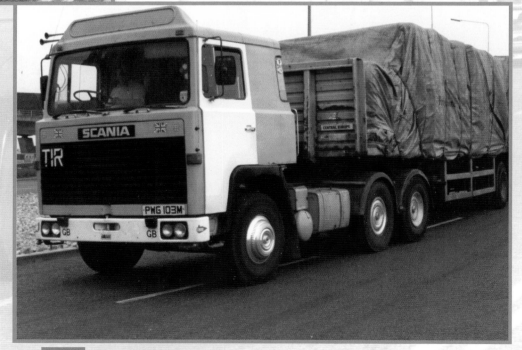

3.10 *A 1974 Scania six-wheeler in Ferrymasters colours pulling a full load into Dover for shipment. It is very difficult to determine whether this is a 110 or a 140. Note the coach style wheel trims on the tractor unit.*

3.11 *Taken in 1989 at the Spanish border town of La Jonquera, this beautiful Kenworth K100 COE was just one of a convoy of KW trucks from the Swiss company Friderici that was resting up.*

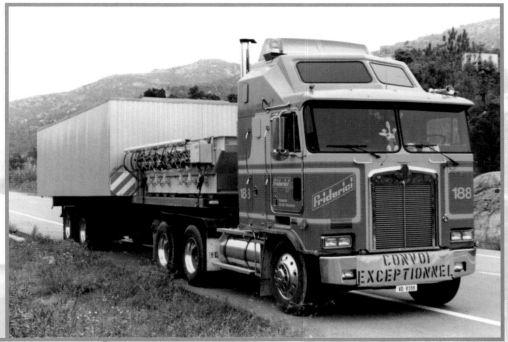

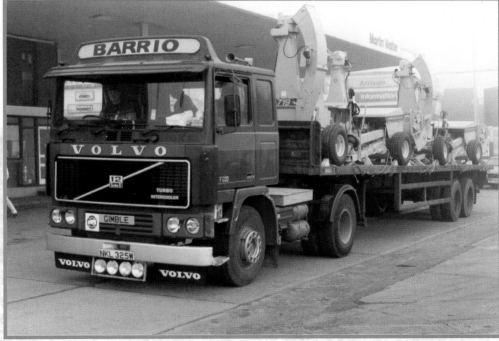

3.12 *A Barrio Volvo F12 with a load of New Holland 719 Forage Harvesters exiting the port of Dover. Barrio hauled anything, anywhere, but its biggest customer was BOC carrying goods for Marks & Spencer, and runs to and from Spain with M&S goods down and fruit and vegetables back were the most common. Barrio traded from 1977 until 2000.*

3.13 *80s styling at its best! This Country and Western fan is proud to display his rig at a show, exhibiting all the extras that were popular at the time, including at least 25 marker lights on the cab.*

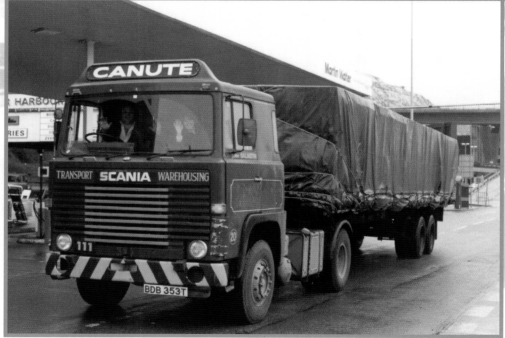

3.14 *'Look mum, no hands!' Canute distribution has come a long way from when this picture was taken of a second-hand Scania they were running. This Scania was still sporting some of its former Scottish owner's livery, Canute now run a huge fleet of trucks from various depots around the country on large contracts such as Wilkinsons Supermarkets.*

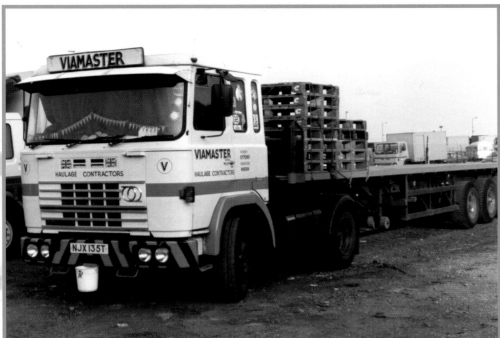

3.15 *A Seddon Atkinson from the Yorkshire company of Viamaster with neatly roped-on empty GKN pallets. Nowadays a couple of ratchet straps would replace the ropes.*

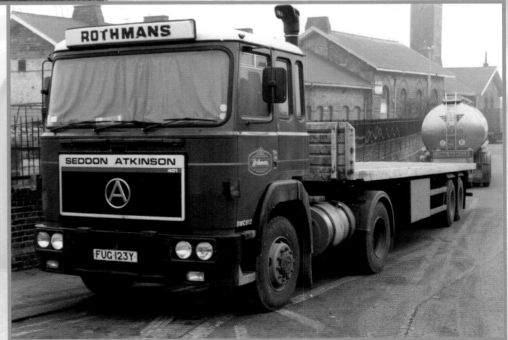

3.16 *A Seddon Atkinson 401 parked by the old railway buildings near Western Docks, Dover. The Rothmans livery is a bit of a puzzle – is it a former race transporter or similarly sponsored events vehicle, or were the tobacco company the owners or previous owners?*

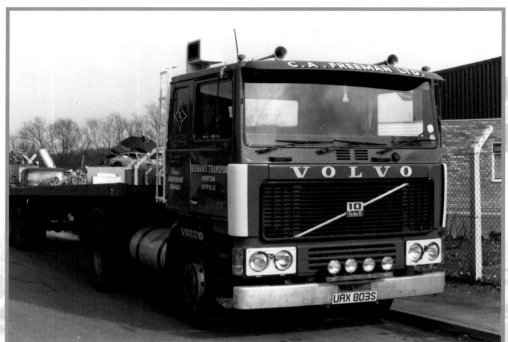

3.17 *Volvo F10 of Cyril Augustine Freeman, an owner driver from Kenton, Suffolk. Cyril's son, Tim, drove a yellow and red Volvo F88, GPW 344N for him which was replaced by Volvo F10, UAX 803S that came from the well known Mr Peckham fleet of Norfolk. Most of Cyril's work was out of Rowhedge dock, Colchester, Essex. He carted bundles of wood for Northern Wood Terminals, who still today ship into Ipswich West Bank. The green Volvo was hit by a Volvo F7 on the road into Rowhedge dock and Cyril bought a black Volvo F10, XPW 692S to replace it. Tim subsequently bought the black F10 from Cyril and set out as an owner driver, something which he still does today with a striking Volvo FH12. The F10 however met an untimely end, catching light and burning out in Ralph Morton's yard in Ipswich. In between flatbed jobs carrying cabbages, UAX 803S pulled a bulk tipper fitted with a donkey engine. Tim's brother Karl also became an owner driver and nowadays drives a Scania R580 V8 on dock traction work.*

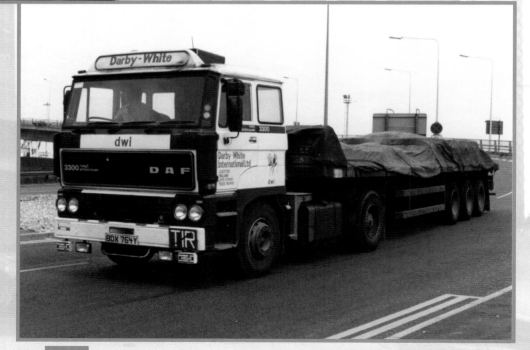

3.18 *A Darby-White International of Leicester DAF 3300 drops down into Dover from the Whitfield direction. Note the air-con unit on the roof, and the neat step/catwalk arrangement.*

3.19 *Denby of Lincoln was a big user of flatbed trailers for continental work. This DAF 2800 with the nickname 'Sailor' painted on the bumper follows the usual Denby trait of removing the truck maker's badge from the front of the cab. Mostly this was to allow the fitment of the name 'Denby' in large white lettering to the cab front, although this truck has none.*

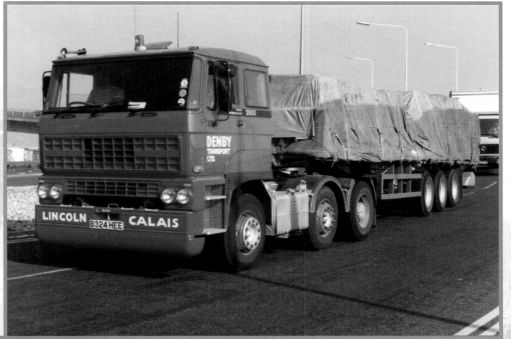

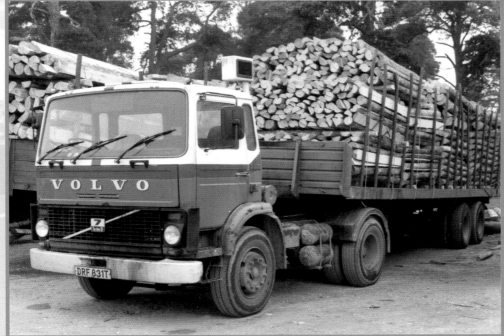

3.20 *A Volvo F7 day cab of Mr Peckham of Norfolk looks dwarfed by its load of cut timber. As a magazine of the time reported, Ken Peckham tried to give one of his drivers a new F7, but he couldn't prise him out of his beloved F86, so he gave up and sold the F7. The family firm is still trading today.*

3.21 *Pandoro (P&O Ro-Ro) was established in 1975 for operation of the company's Irish Sea Ro-Ro routes. In late 1983, for its SK Range, Mercedes announced the twin-steer variant of the 1625, the 2025. Offered with three cab options, designated S, M & L, the 2025 had the same OM422 V8 as the 2028, but, developing just 247hp rather than 276hp of the former, it was deemed less extravagant!*

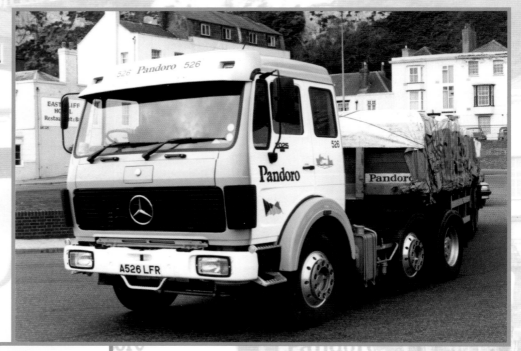

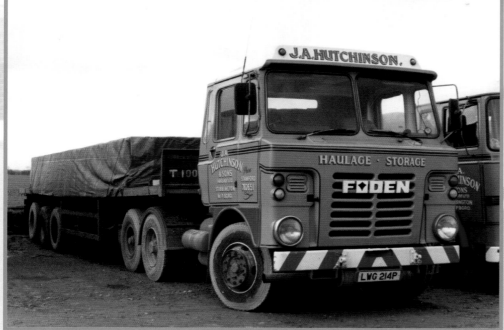

3.22 *The livery of J.A. Hutchinson of Stibbington near Peterborough suits this Foden S80 well. It was either powered by a Cummins or a Rolls Royce and had a tag axle set up and an exhaust mounted under the front bumper.*

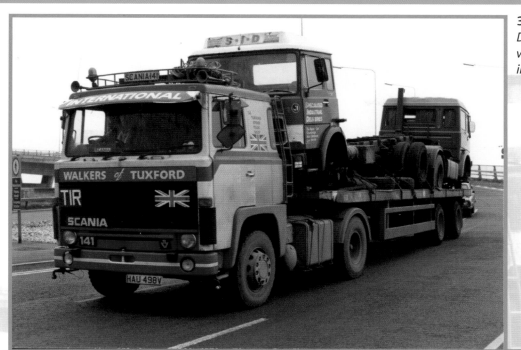

3.23 *A Walkers of Tuxford Scania 141 carries two Iveco units towards Dover docks for export to presumably sunnier climes. Richard Walker was a pioneer of UK truck racing and was a regular sight at the circuits in his Leyland Roadtrain.*

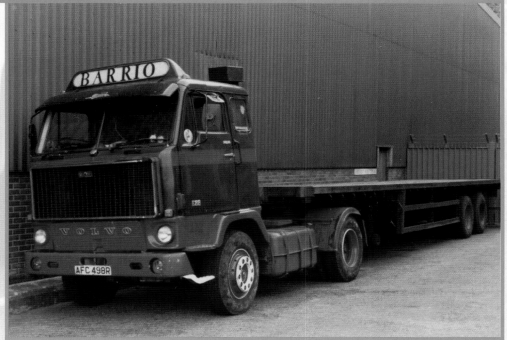

3.24 *Another Barrio truck, this time a 4X2 F88 with tandem axle flat, but it has a strange air intake, possibly for petroleum regulations. Barrio was run by Michael Winston Baldock and was originally from Detling Hill but later moved to Newington, near Sittingbourne. They mostly ran a fleet of Volvos after trying other makes such as Scania and Guy.*

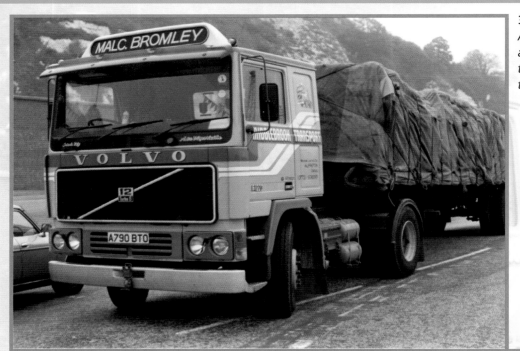

3.25 *Middlebrook Transport of Meadow Lane Industrial Estate, Alfreton, Derbyshire was formed by Malc Bromley and has always had and continues to place the slogan 'A su disposicion' on the front of their trucks. Translated as 'At your disposal' this F12 wears it just below the windscreen.*

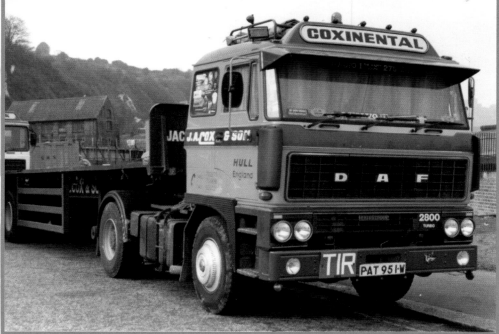

3.26 *J.A. Cox & Son of Hull DAF 2800 fitted with Hadley air horns and marker lights and period Radio 1 sunstrip. Presumably this truck hauled plant machinery or the driver is a fan of Priestman as it carries a plaque on the grill.*

3.27 Herbert Frost bought his first truck in 1950, and since sons Colin and Kevin took over they have steered the company into its sixty-fifth year. Frost's original livery was the same as the Ford tractors on their farm. They had four Volvo F88s in total, one 240 and three 290s of which PNG 397R was one. One was converted into a 6X2 in their own workshop and had double wheels on both rear axles, making it hard to corner! NG is a Norfolk registration and, when new, was supplied by Duffield's of Norwich. Frost bought it from a Mr Warren of Ipswich and originally it was red. Here it sits with a lovely period tractor and trailer on board, all neatly roped down.

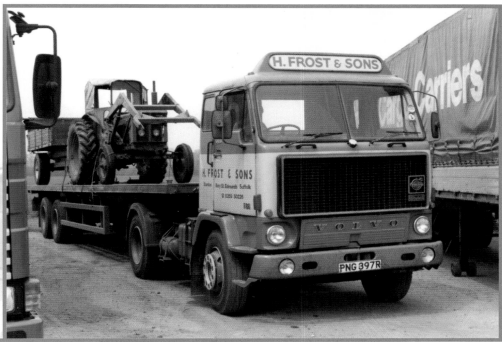

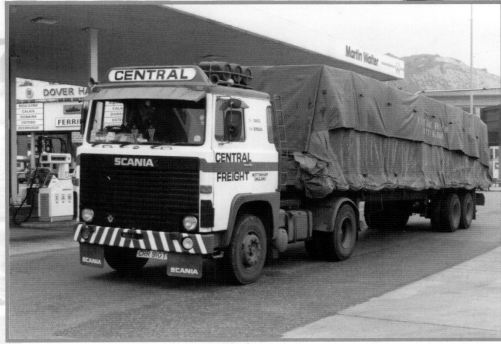

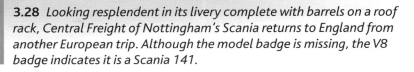

3.28 Looking resplendent in its livery complete with barrels on a roof rack, Central Freight of Nottingham's Scania returns to England from another European trip. Although the model badge is missing, the V8 badge indicates it is a Scania 141.

3.29 *Dave Miller was best known in the 80s for the customised Scania tractor units he operated, most memorable being his Scania 'Aerodyne'. Based in Therfield in Surrey, Dave's two trucks carried farm machinery, the other truck a customised 142 driven by Anthea, his wife. The 142 passed onto Ken Peckham and is still on the show circuit today. This neat Scania 81 rigid was driven by Dave himself.*

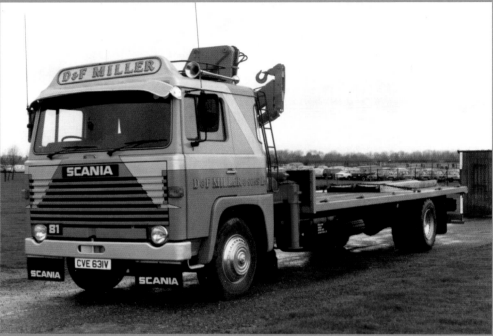

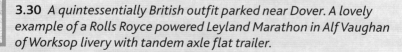

3.30 *A quintessentially British outfit parked near Dover. A lovely example of a Rolls Royce powered Leyland Marathon in Alf Vaughan of Worksop livery with tandem axle flat trailer.*

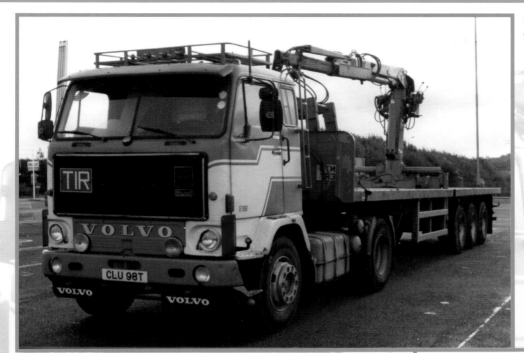

3.31 *With its roof rack and spotlights, this left hand drive F89 has a very Scandinavian look, pulling a brick and block tri-axle trailer.*

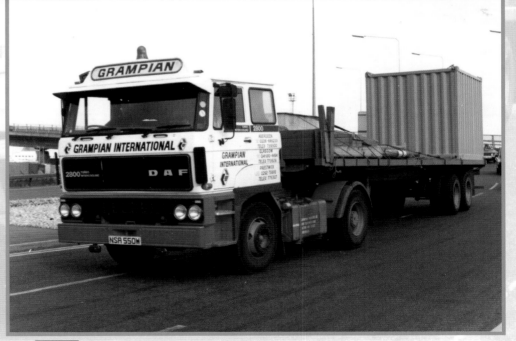

3.32 *Hailing from Aberdeen, Grampian International were heavily involved in transport for the oil industry with a fleet of flat trailers, and this DAF 2800 is carrying an equipment container for a rig support vessel.*

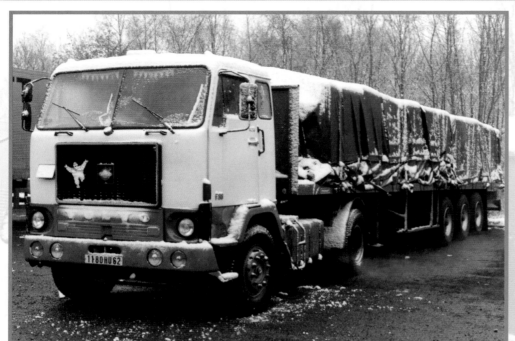

3.33 *A very cold looking scene! A J.C. Fiolet Volvo F88 with tri-axle Fruehauf trailer and neatly sheeted load runs its engine to try to keep warm at Gate Services in Kent.*

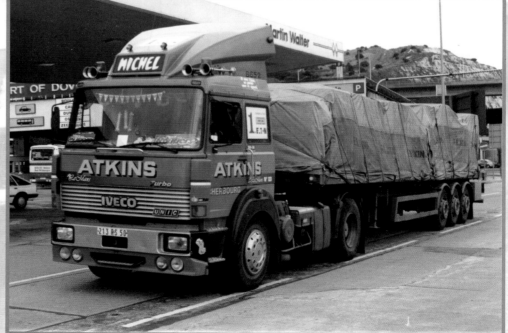

3.34 *F.B. Atkins of Findern, Derby had many strings to their bow. As well as running a cafe near their yard in Derbyshire, they had several depots in the UK and one at Cherbourg. This French based Unic powered Iveco with sheeted load is exiting Dover port.*

3.35 In 1974, the French government ordered the takeover of truck and bus manufacturer Berliet by Renault which, along with its other subsidiary Saviem, became Renault Vehicules Industriels, or RVI. The trucks continued to be badged into the 80s as Saviem and Berliet, and after RVI gained a share in Mack Trucks of America they rebranded as just Renault. This Berliet TLR280 from Cambrai, France was an unusual sight on British roads as was its equally unusual flat trailer.

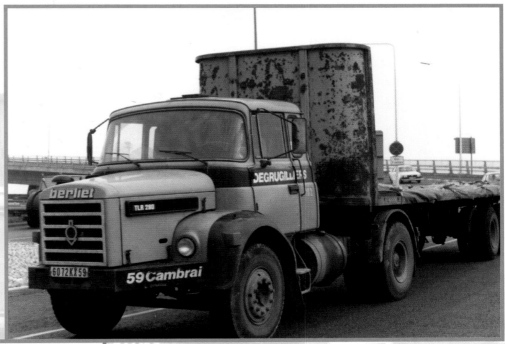

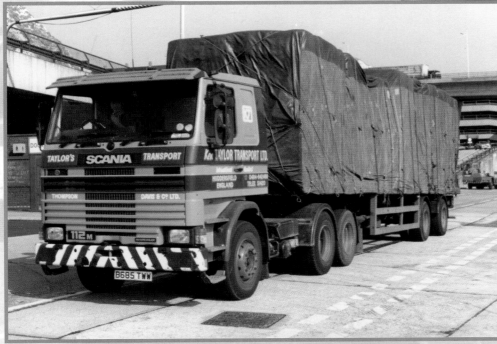

3.36 B685 TWW was new to Ken Taylor Transport of Huddersfield in 1985. Taylors specialised in European transport, in particular for wool freight forwarder Thompson Davis and Co. of Bradford, and here family member Glyn Taylor exits Dover after returning from Belgium with woollen bales. The Taylor name is still a regular sight on the roads today, but these days limits itself to UK work only.

4

Fridges and Boxes

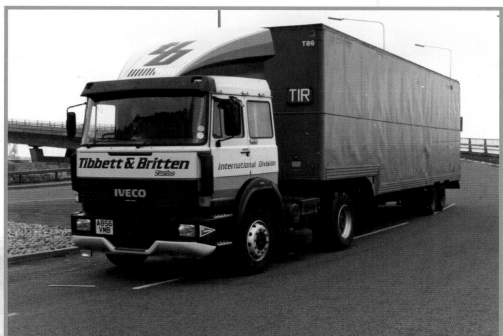

4.1 *In 1958 John Tibbett founded a company to pioneer the transport of hanging garments, and was joined in 1963 by Frank Britten. In 1969 a 75% share in the company was sold to Unilever/Dutch Railways to finance expansion. In 1984, John Harvey led a management buy-out and in 1986 the company floated on the London Stock Exchange. In 2004 transport giant Exel bought Tibbett & Britten and abolished the name. This Iveco 190-30 with garment trailer negotiates Jubilee Way on its approach to Dover.*

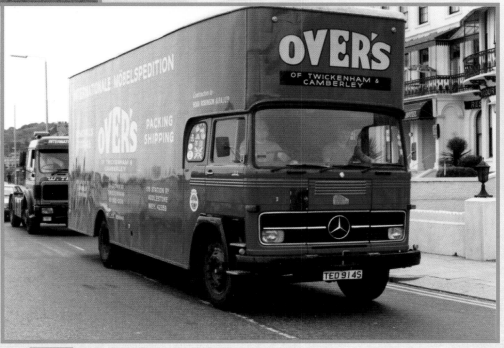

4.2 *It seemed only right to feature a removals lorry in this category and this is a beauty. A Mercedes LP1319 from Over's of London makes its way towards Dover Eastern Docks for a European trip.*

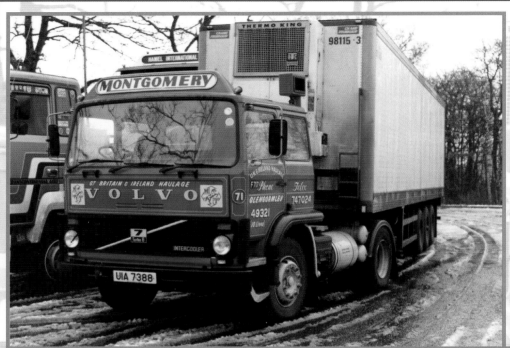

4.3 A Volvo F717 of Montgomery Transport from Glengormley, Co. Antrim, Northern Ireland. Formed in 1970, with one tractor unit, the haulier is a privately owned business that is part of the Ballyvesey Holdings Group that also own Montracon trailers.

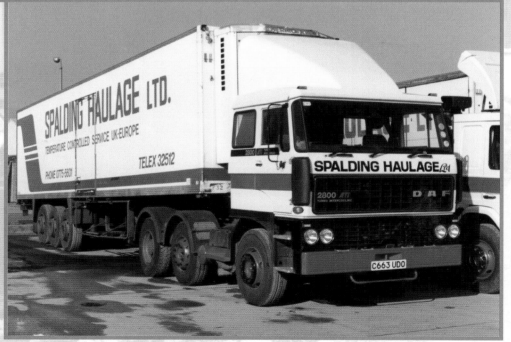

4.4 Don Beecham started Spalding Haulage which was purchased by BOC Distribution in 1992, and has subsequently changed its name to GIST Ltd. Spaldings were well known for running a fleet of smart fridge trucks, and this DAF 2800Ati is no exception.

4.5 *ANC Parcels based in Stoke on Trent had built up a nationwide parcel service with franchised depots until purchased for £20m in 2006 by FedEx. This Scania 92M with tandem axle trailer is typical of the lightweight trucks used by parcel companies in the 80s.*

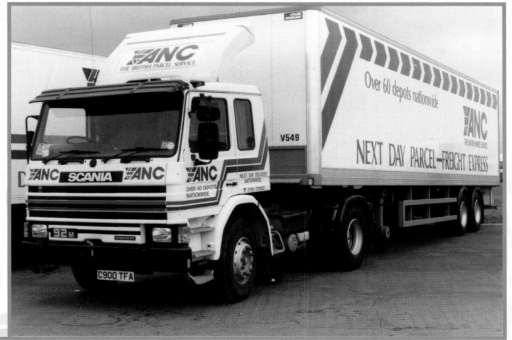

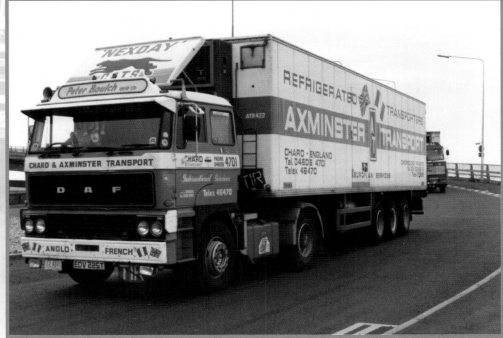

4.6 *Peter Baulch's Chard and Axminster Transport Services was another English company that established a depot in France, and it made sense therefore that it was a user of Renault trucks, but also relied upon a large number of DAFs. In later years, C.A.T.S. had Leyland Roadtrains painted in Danzas livery but still featured the silhouette of the cat on the spoiler.*

4.7 There's not much to say about this J.R. Smith of Tring, Herts, DAF 2100, it is very plain and simple, enhanced by the addition of a sun visor, air horns and corner dirt deflectors.

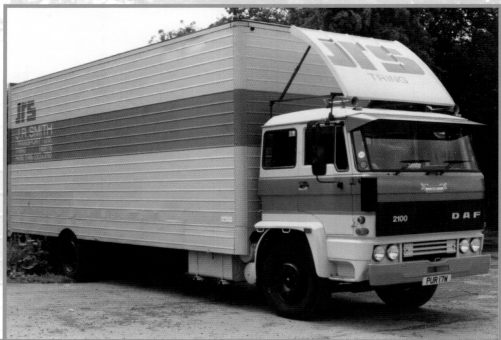

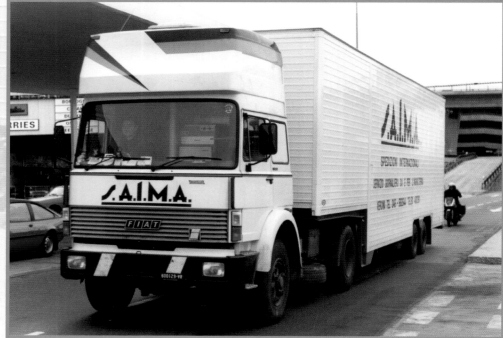

4.8 A Verona registered Iveco with an unusual rooftop sleeper pulling a furniture trailer. It carries the name Miatello on a small sticker, which are a hotel supplies company, including equipment such as dishwashers, cookers and refrigerators. Presumably the sleeper is to enable a second person to be carried to help unload the bulky items, although this right hand drive truck appears to be single-manned on this trip.

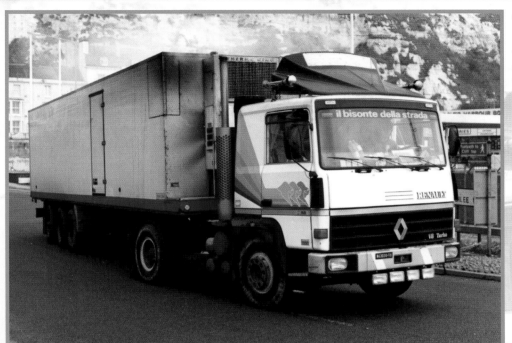

4.9 *Smokin'! A Turin registered Renault R360 bearing the slogan 'Bison Of The Road' prepares to climb out of Dover. Note the rear steering axle on the Thermo King powered trailer, the large section of repaired bodywork on the front top corner and the unusual way the trailer chassis seems to continue forward to sit flush with the bottom of the fridge unit.*

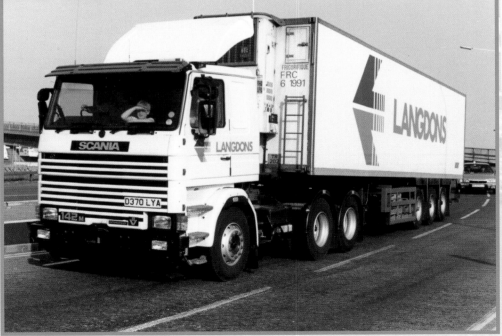

4.10 *'I see no ships!' An unsecured child would be frowned upon nowadays but the 80s were different times. Langdons of Taunton in Somerset used to use owner drivers with trucks painted in their own livery for the haulage of their trailers, but now have a large own account fleet based at many depots around the UK. Langdons were also renowned at the time for running an extremely popular truckstop with fuel and accommodation facilities at their base close to the M5 motorway.*

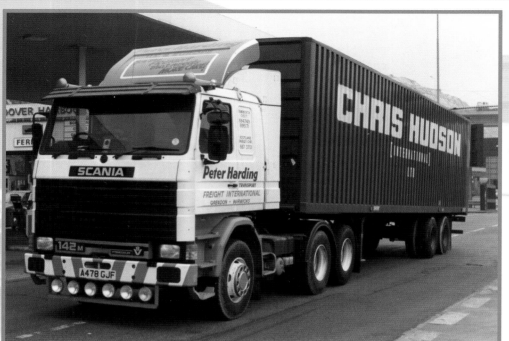

4.11 Peter Harding owned this Scania from new. The trailer it is pulling is one of 20 bought new by Chris Hudson, and along with 20 second-hand Fruehauf galvanised box trailers they were used on the contract for IBM computers in Scotland. Peter was asked to provide trucks for this contract, and when Hudson's went into receivership, the Dutch partner of the business formed a new company, Cargo Care, and carried on with the IBM contract. Peter secured the continuation of the work with the new business partner and was in fact Cargo Care's first UK subcontractor.

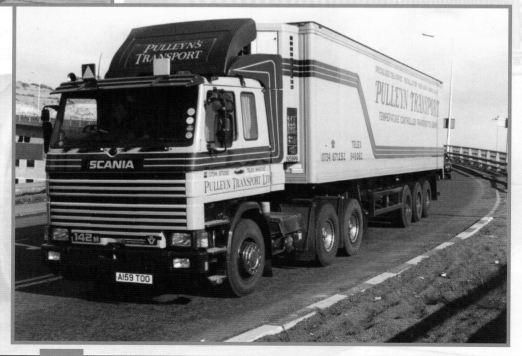

4.12 Then based in Rose Kiln Lane, Reading, this smart Pulleyn Transport Scania 142 sets out on another European trip. Export loads then were for top notch customers such as Sony, and a typical backload would have been fruit and vegetables from Spain, hence the drivers addition of the Spanish style warning placards on the roof.

4.13 *This stunning Danish Scania 142 was a regular visitor to the UK. Converted into a high roof Aerodyne style sleeper, it also featured a deep chrome bumper with bull-bar, twin exhaust stacks, chromed ladder, American style rear mudguards, polished custom made fuel tanks and a large chequer plate catwalk.*

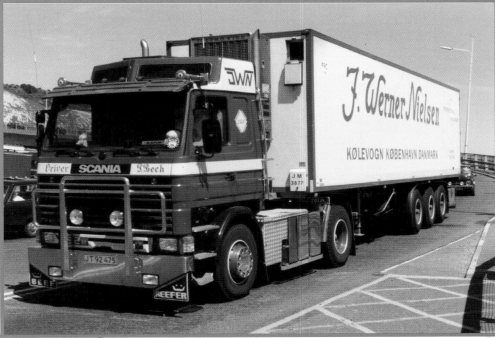

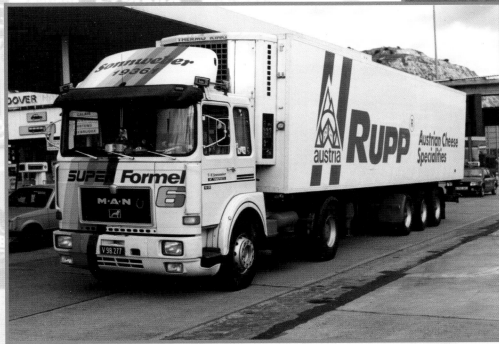

4.14 *This Austrian M.A.N. 19.36 has a striking factory promotional livery as it enters Dover with its load of cheese. He had better keep an eye on his mirrors though, trouble is never far away!*

4.15 *A Gibraltar registered Scania 142M from Pegasus, owned by a Mr Vialle, they had an office on the marina in Gibraltar. Shipping out via Poole or Portsmouth, the trucks would take fresh supermarket supplies out to Gibraltar and backload fruit and vegetables back from southern Spain.*

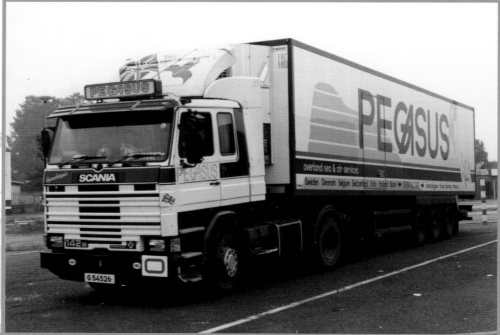

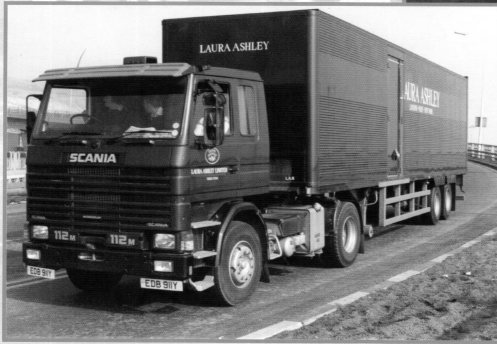

4.16 *Laura Ashley clothing is quite often double-manned due to security issues, even today, and this Scania 112M actually appears to have three occupants on this European trip!*

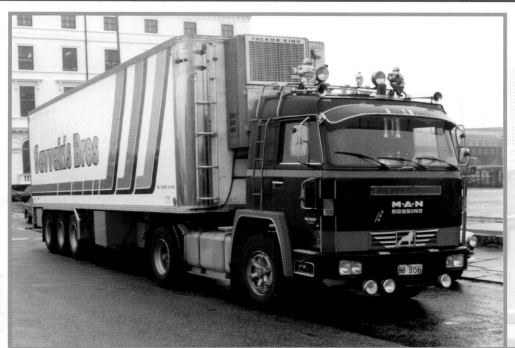

4.17 M.A.N. took over fellow German bus and truck maker Bussing in 1971, and immediately withdrew all Bussing models, so this will date this truck to at least 10 years old when this photo was taken. After a public outcry, M.A.N. introduced a series of under floor engine commercials sold as M.A.N. Bussing. This Greek 19.320 hailed from Athens and looks splendid with its colourful trailer.

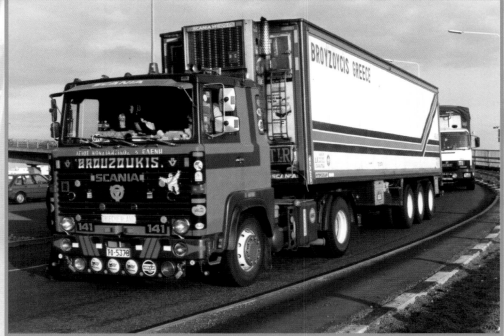

4.18 A much personalised Greek Scania 141! Complete with horseshoes, Michelin man, anchors, marker lights and stickers galore, even one up on the fridge motor, there is no doubt that this driver loves his truck!

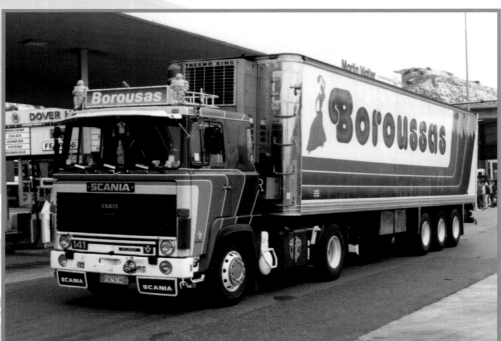

4.19 *A stunning paint job on this Greek Scania 141, with matching reefer trailer. Note the trailer had twin wheels on each of the three axles. Also of note is the Mack Bulldog mascot mounted on the cab nameboard, framed by the twin coloured Michelin men!*

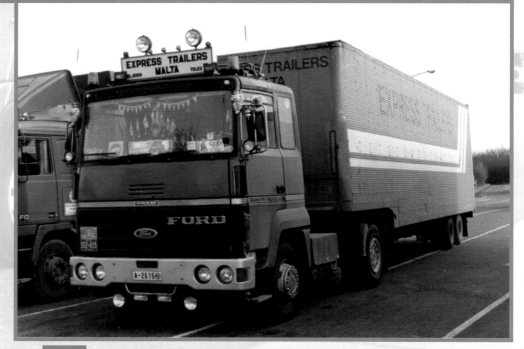

4.20 *Express Trailers from Malta have been long-time visitors to the UK and still travel the long distance today. This Ford Transcontinental 2 is not in the usual livery seen. I suspect 'Snoopy' is a religious man!*

4.21 *John Howard of Grimsby operated a successful cold store and haulage business. He sold the company in 1996 but bought it back in 2002 and renamed it SAL Commercials. Here one of his Scania 112s powers out of Dover docks.*

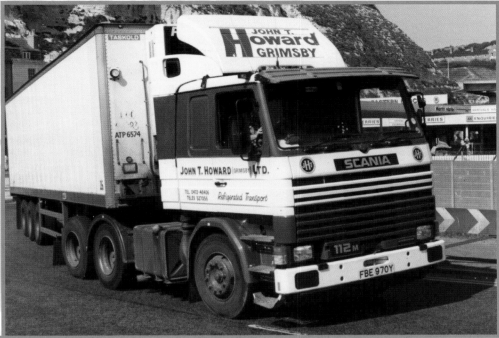

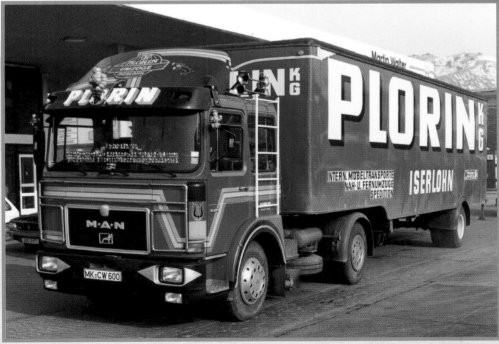

4.22 *A M.A.N. 16.220 with a furniture trailer from western Germany. The trailer is an interesting design, but more interesting is the driver's collection of Smurf figurines mounted on little shelves in his windscreen!*

4.23 Brit European's Ron Carman anticipated well in advance changing regulations to weight limits in the UK and ordered high volume M.A.N. drawbar outfits long before the rules were changed. The company had a knack of speccing vehicles specifically for certain types of haulage, and here we see a Belgian registered Scania 111 with a carpet trailer, fitted with front doors to ease loading and unloading of the large rolls carried. By 1986 B.E.T. had European bases in Zeebrugge, Calais, Milan and Rotterdam.

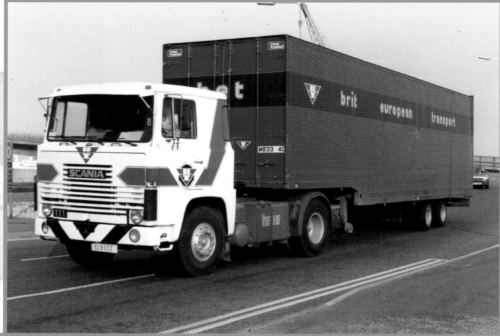

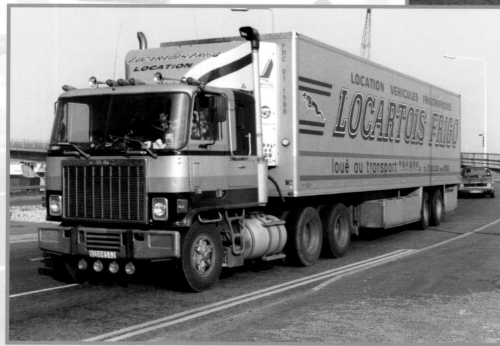

4.24 Trans Artois Frigorifiques (T.A.F.) ran a number of these impressive GMC Astro units on international fridge work but they were usually in the company colours of red and white.

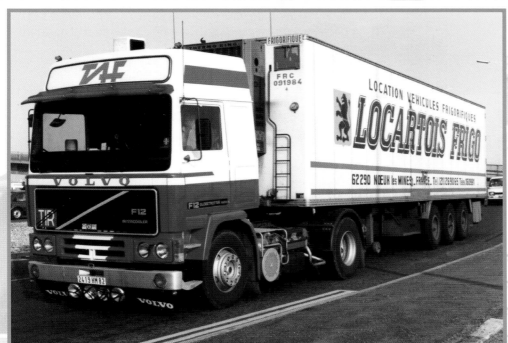

4.25 *A Volvo F12 in the usual colours of T.A.F., the Pas de Calais Company were seen hauling reefers all over Europe. This unfortunate driver has suffered some damage to the lights mounted under the bumper.*

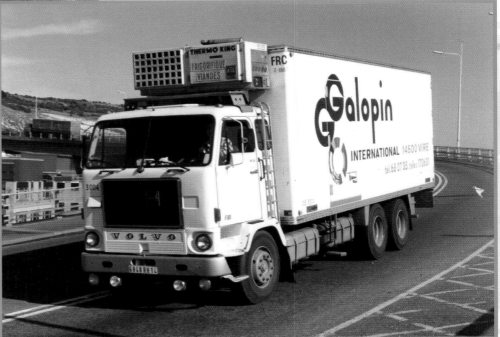

4.26 *A delightful Volvo F88 rigid fridge truck from Vire, near Caen, France heads towards home.*

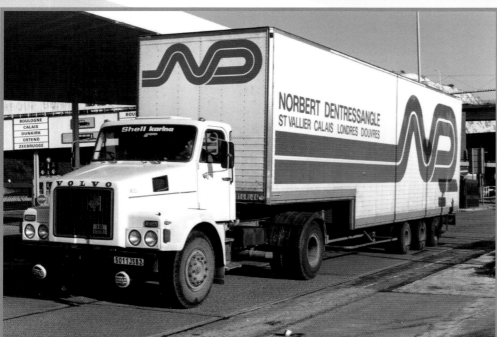

4.27 A much smaller than today Norbert Dentressangle ran this Volvo N10 day cab unit with tri-axle step frame box trailer from a northern France depot as the truck is registered in the Pas de Calais region.

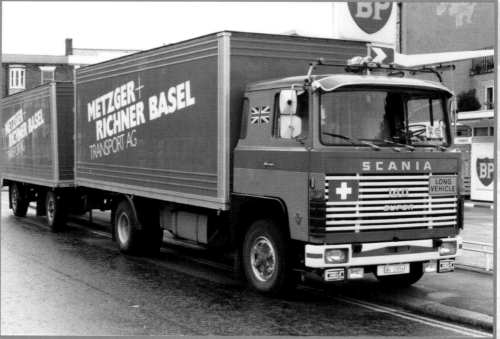

4.28 A gorgeous Scania 140 drawbar from Basel, Switzerland stops on the seafront in Dover on the way to the ferry terminal. Of interest is the very Swiss looking A-frame drawbar trailer with split rim wheels.

4.29 *The book would not be complete without a typical 80s Spanish fridge truck, and here is one example, a Pegaso 1234. In 1981 International Harvester purchased a 35% share and took charge of the management, but this only lasted until 1983–84. Pegaso's parent company ENSA also bought Seddon Atkinson in 1983, and the Cabtec agreement with DAF in 1984 saw all three makers' names appear on the same cab shell. In 1990 ENSA was absorbed into the IVECO group.*

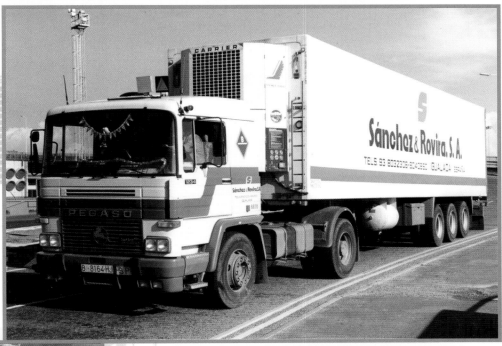

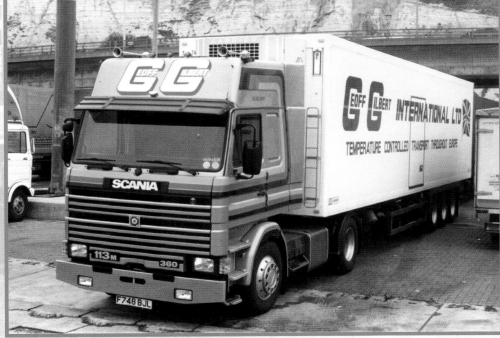

4.30 *An 88–89 registration means this beautiful left hand drive Scania 113M of Geoff Gilbert's well known fleet just sneaks into the book! A Dutch built Estepe high roof really compliments this cab well, and was offered to operators who wanted the additional living space but did not want to buy a Volvo Globetrotter.*

4.31 *Although today F. Edmondson & Sons run Mercedes Benz trucks, in the 80s they had a large number of Scanias, both tractor units and rigids. Based in Morecambe, Lancashire they run a regular service between England and Italy carrying furniture and bought Febland Europa's depot in Novara from them when they closed.*

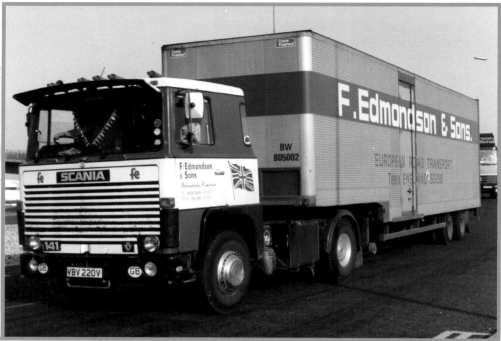

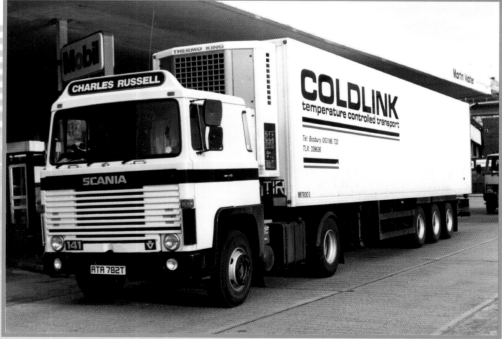

4.32 *Long-time Scania users Charles Russell of Cheltenham, Gloucestershire usually had trucks painted in their livery of orange but this outfit was plain white and carried the name of Coldlink from nearby Bosbury, a company that was bought by TDG subsidiary Novacold.*

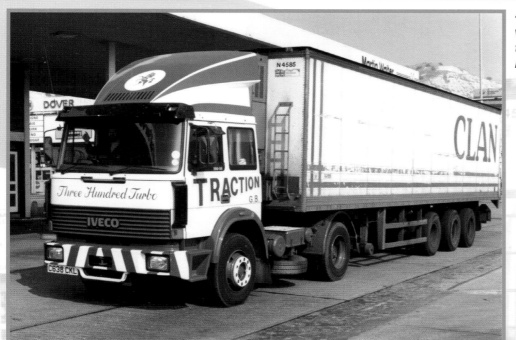

4.33 Infamous truck racer of the time, Nigel Fry, is himself at the wheel of his own truck here. Traction GB was a Kent based company that ran some very distinctive trucks in its time and this Iveco 190.30 is no exception.

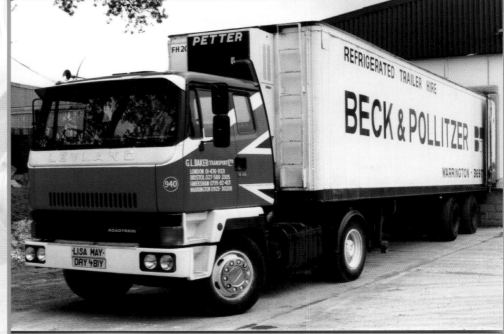

4.34 G.L. Baker was owned by BOC and was later rebranded as BOC Baker. The BOC group also owned other recognisable names from the time, like Transhield. This Leyland Roadtrain in Baker colours was at Northborne, Kent.

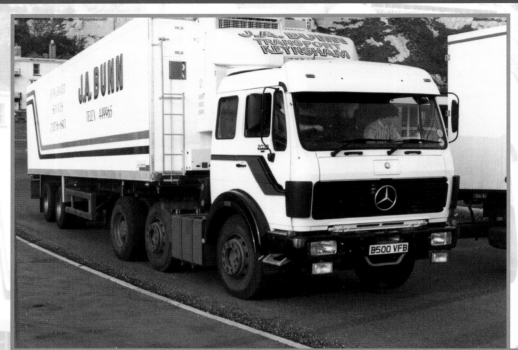

4.35 J.A. Bunn of Keynsham operated out of Stockwood Vale and the firm eventually was purchased by Gagewell. Here one of their Mercedes 2038 re-enters the UK through Dover, note the wing tops are missing, something which VOSA would pay attention to today.

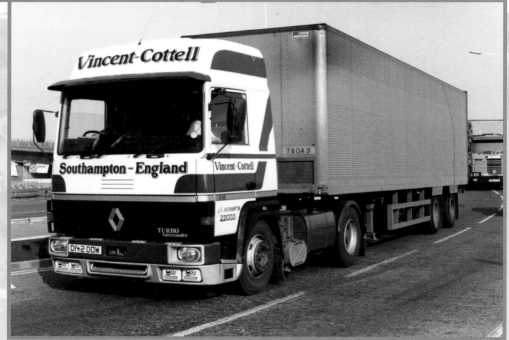

4.36 D142 DOW was owned by Richard and Angie Evans, who ran R&A Freight from West Wellow, Southampton. It was painted in the livery of Vincent Cottell, an international freight forwarder based near Southampton docks.

4.37 *Purfleet-based Kentvale specialised in the transport of vehicles, in particular Land Rovers, and were purchased in recent times by E.M. Rogers of Northampton. The Kentvale name is being kept alive however, although the livery has changed.*

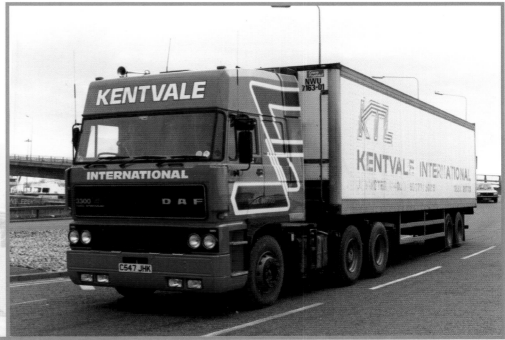

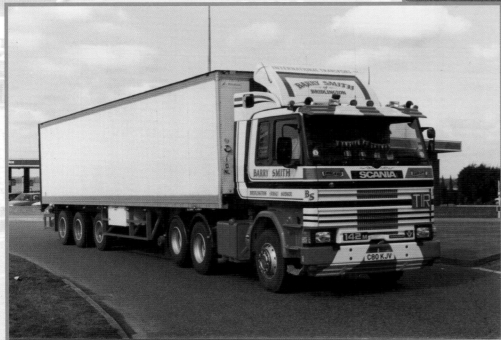

4.38 *Barry Smith's first truck as an owner driver was an Atkinson eight-wheeler fitted with an automatic gearbox which only lasted a year before it was changed for a ERF tractor unit. A Scammell was next and a Scania 110 followed that. Barry has also owned a Volvo F86 and a F12 before he settled on this Scania 142 6X2 with striking livery.*

4.39 *Gask Contractors from Perth, Scotland were part of the I & H Brown group. Browns were well known for running a fleet of Mack R700 cabover units and one of these is seen behind this lovely Volvo F7 eight-legger fridge.*

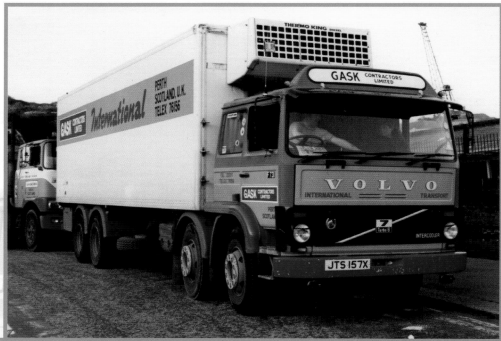

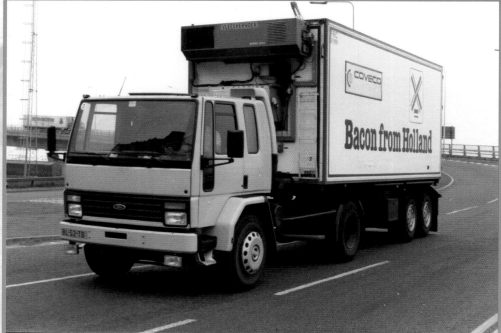

4.40 *De Jong used to bring some unusual short fridge trailers into the UK for Laros carrying bacon, and this trailer of theirs is being pulled by what is probably a demonstrator. The Ford Cargo is vastly different from their usual mix of Scania, Volvo and M.A.N. although they did run Transcontinentals so there is a link with Ford.*

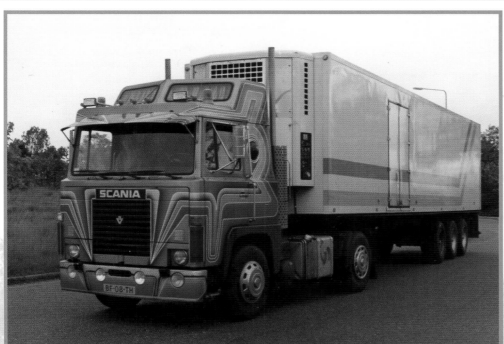

4.41 *The stunning Scania from Holland of V.D. Bogert. This truck had extensive cab modifications, most notably the 'Aerodyne' roof and the bubble window in the sleeper, as well as a spectacular paint job, and won first prize in the working truck section at the Truckstar show at Zandvoort in 1983.*

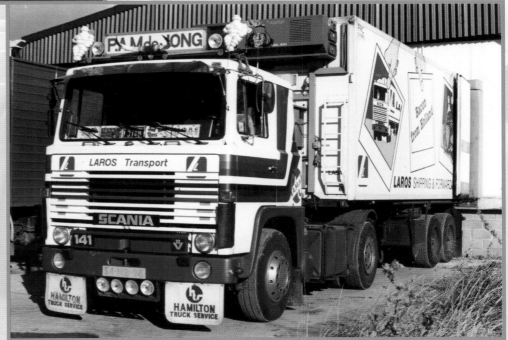

4.42 *A more usual truck for P.A.M. De Jong – a Scania 141, seen at Kent Salads depot at Northborne, Kent.*

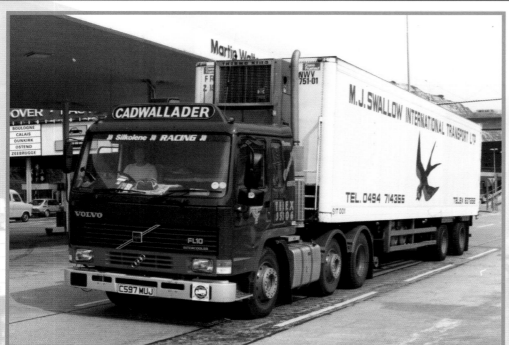

4.43 *A Volvo FL10 of Cadwallader of Oswestry, Shropshire. 'Caddies' were veteran international fridge operators by the 80s and were a company that was popular with its drivers. In 1996 it decided to close the bulk of its business, blaming the BSE crisis as the main reason. At the time of closure the company had 106 trucks and 200 trailers, with 110 drivers being made redundant. Owner Russell Cadwallader's two sons, John and David, carried on the family name with a trailer rental business.*

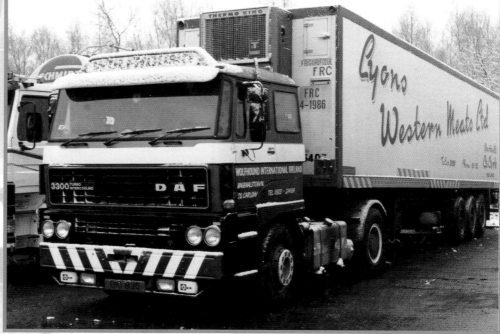

4.44 *A wintery scene at Gate Services on the A2 in Kent. A Wolfhound International DAF 3300 from Bagenalstown near Kilkenny, Ireland parked up during a snowstorm.*

4.45 When most other Irish drivers were cruising around Europe in Scania and Volvo trucks, this Hino must have been a real comedown! Hino established dealer franchises in Ireland quite successfully for a time, but the tractor units never really caught on anywhere else, however the tippers proved a tough, reliable machine and sold in reasonable numbers in England, especially the eight-wheeler chassis.

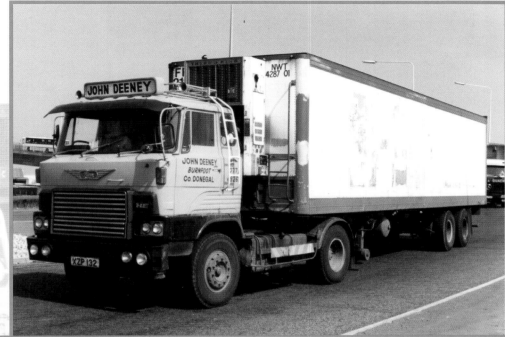

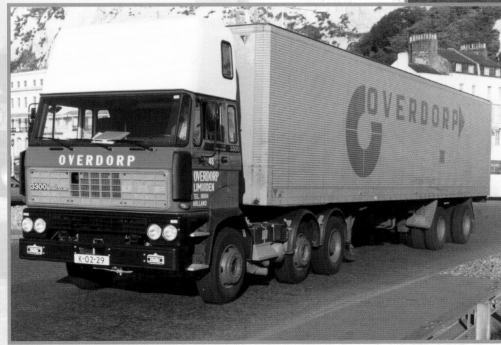

4.46 An example of using all the available trailer length within the law, this Dutch DAF 3300 of Overdorp from IJmuiden uses a day cab with a roof top sleeper pod.

4.47 The origins of the number plate of this Magirus Deutz 360-V12 are unclear, there are no obvious identification symbols like there are nowadays. Italian number plates were always tiny little things and this is a large plate. However, the CB handle 'Piedone', possibly named after the popular Napoli TV detective of the 80s 'Piedone' (Bigfoot) Rizzo, and the tricolour flag painted on the grill lead to the assumption that it is, after all, Italian. The company was based in the southern town of Salerno on the picturesque Amalfi Coast, and the trailer is unusual in that it looks like a fridge body has been plonked down onto a Viberti flatbed trailer.

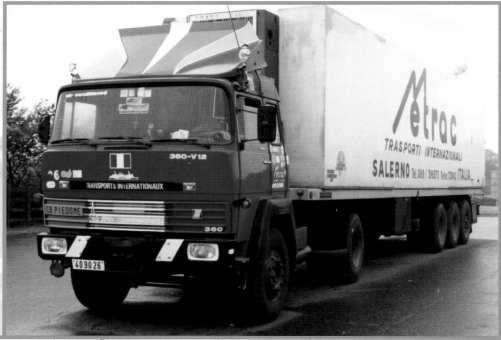

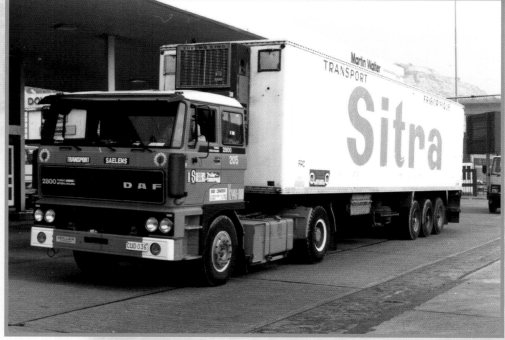

4.48 Sitra (Saelens Intertransport) from the town of Ypres in Belgium close to the French border ran a fleet of instantly recognisable fridge trailers and tankers in the 80s, and are still in business today. This DAF 2800 in the traditional livery of orange is departing Dover with its Thermo King powered reefer, of note is the towing bar neatly fastened across the chassis of the unit.

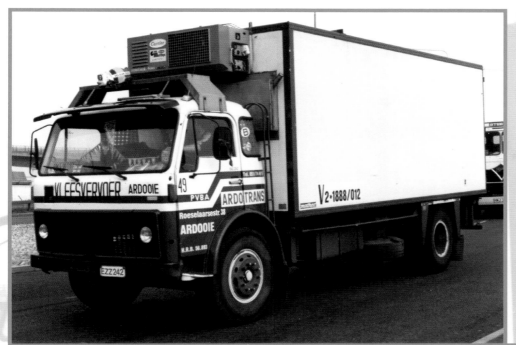

4.49 *A delightful Volvo F86 4X2 rigid with fridge body prepares to exit the UK. Carrying meat, it's not that far once across the channel back to the yard at Ardooie near Roeselare.*

4.50 *Wow! In the 80s we were prepared to be far more individualistic when customising our trucks. Complete with multiple cow horns, multiple spot and marker lights and a spot of airbrushing, the driver of this French Mercedes has it all going on!*

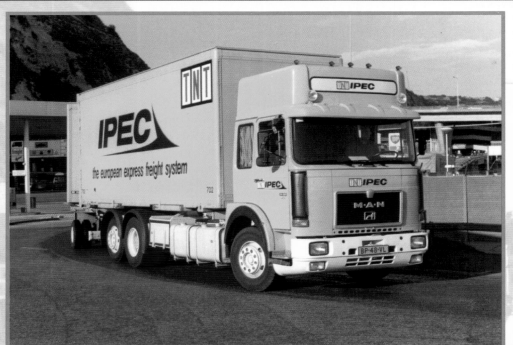

4.51 A very handsome cab roof conversion of this M.A.N. 24.361 drawbar carrying parcels in demountable bodies. At this point TNT had taken over IPEC and had started adding their name into the livery in readiness for complete absorption.

4.52 In 1977, Dennison Trailers of Rathcoole, Dublin started manufacturing trucks. Its founder, George Dennison, had built up a successful trailer building business which was sold to Crane Fruehauf, and then truck manufacturing took over. Fitted with either Rolls Royce or Gardner engines and a Motor Panels cab, they had Fuller gearboxes and Eaton back axles. In 1979 they started fitting Sisu cabs from Finland but in 1981 due to fierce competition Dennison reverted back to trailer manufacture.

4.53 *American trucks were chosen for their sheer ruggedness and durability, plus the lucky driver ended up with a sleeper section much larger than normal European trucks. However, this White Road Commander 2 of Irish haulier Murphy International has a very modest sleeper cab, but is interestingly right hand drive.*

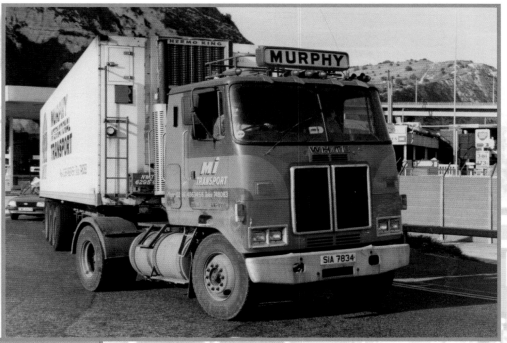

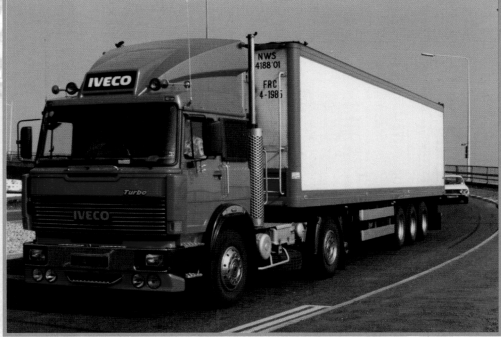

4.54 *In the early 80s Iveco offered a 'Special' edition of its Third Generation 190 Series. Fitted with goodies such as chrome bumper, grab handles, twin exhaust stacks, wheel trims and air horns, under bumper air dam with lights and twin CB aerials it was intended to appeal to the owner driver or haulage firm looking for a flagship. This left hand drive 190.38 from Ireland is a good example of a 'Special' as it approaches Dover port, trailed by an Austin Maxi.*

5

Tankers

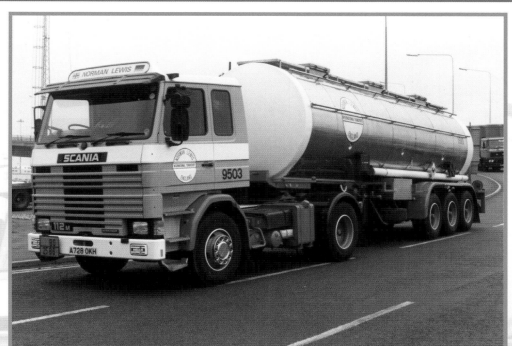

5.1 *Based in Hensall, North Yorkshire, and established in the 1970s, Norman Lewis tankers were a regular sight on European roads and had a base in Holland and regularly loaded in BASF in Ludwigshafen in Germany, hence the German flag on the nameboard. The 70 truck fleet was taken over in 2009 by a team of its managers from the parent company of Simon Storage, who themselves acquired the company in 2001.*

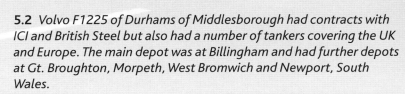

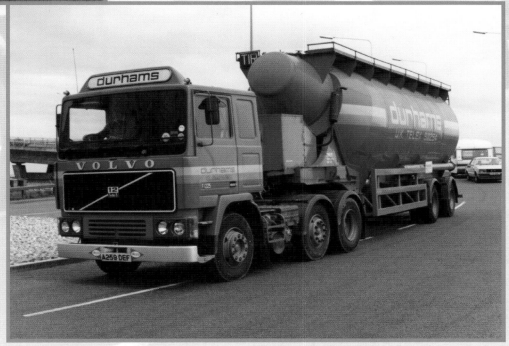

5.2 *Volvo F1225 of Durhams of Middlesborough had contracts with ICI and British Steel but also had a number of tankers covering the UK and Europe. The main depot was at Billingham and had further depots at Gt. Broughton, Morpeth, West Bromwich and Newport, South Wales.*

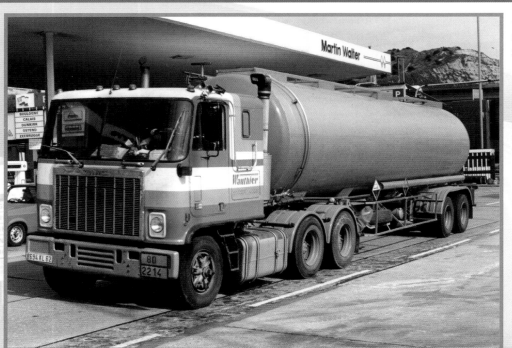

5.3 *Wauthier of Carvin, to the south of Lille, France ran some interesting trucks on tanker work, and this GMC Astro is no exception, seen here with a load of acid in a tanker.*

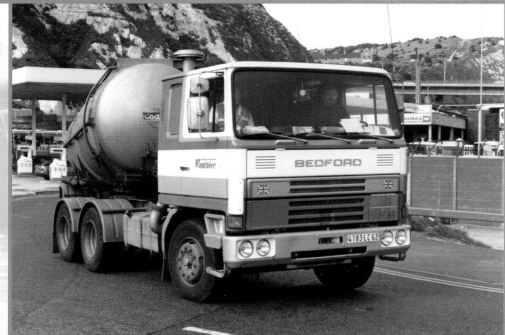

5.4 *Another Wauthier vehicle, this time a six-wheeled Bedford TM proudly displaying the British origins of the truck manufacturer, again with a tanker containing acid.*

5.5 *A wonderful veteran Scania L111 from the French region of Maine-et-Loire departs England with its Coder trailer. Coder tankers were a French company that specialised in tar tanker manufacture.*

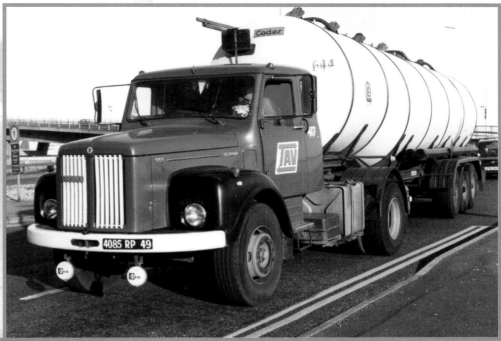

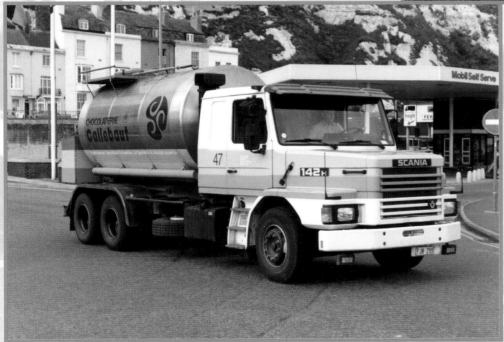

5.6 *Heaven for a sweet tooth! This Scania T142H six-wheeled rigid was seen many times in Dover by David and delivered liquid chocolate from Belgium.*

5.7 *This M.A.N. 22.321 twin steer was the first six-wheeled unit Locks bought, and was owned from new. Locks had been waiting for a Seddon Atkinson to be delivered and when it never materialised they went out and bought this truck, and were more than impressed. Note how the side sleeper windows had to be blanked out for the pet regs of the time.*

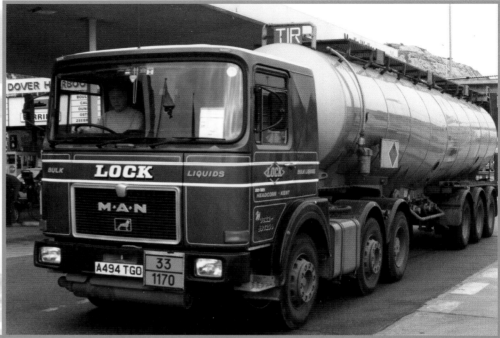

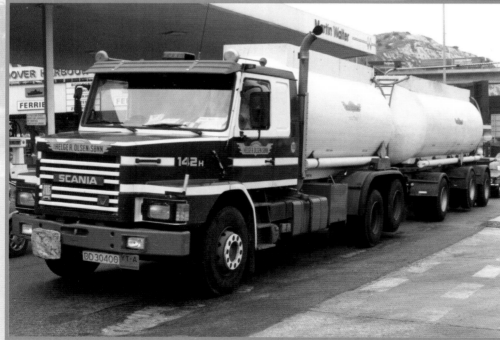

5.8 *An unusual outfit to be seen in Britain, this lovely Danish Scania T142H is quite possibly empty due to the fact the tag axle on the rigid and the second trailer axle are lifted.*

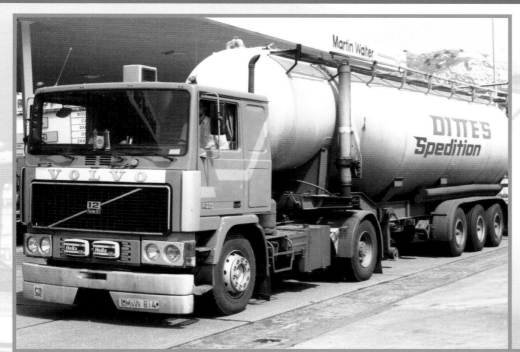

5.9 *This substantial looking outfit from the Limburg region of Germany sports a deep double bumper and Heller lights mounted into the cut out grill. Of note is the bulk tanker's tipping ram which is not mounted at the front of the tank as in most cases, but is sited on the side of the tapered section.*

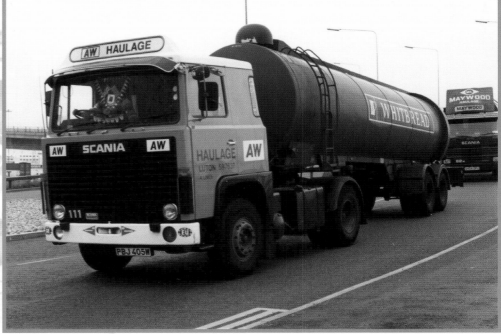

5.10 *Gary Pearl drove PBJ 405W when it was originally owned by Russell Davies and painted in their famous livery. It was used on their Dipgrove work, Dipgrove being the UK agent for Great Britain Nigeria Line of Wolverhampton. AW of Luton bought it and resprayed it orange and it's seen here approaching Dover with a Whitbread tanker followed by a Maywood Scania 82M pulling an identical trailer.*

5.11 *A Brown's Seddon Atkinson 401 tanker 'shipping out'. The aluminium wheels of the unit and the polished food grade tanker made this rig stand out.*

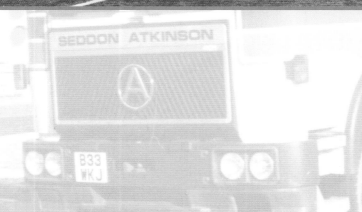

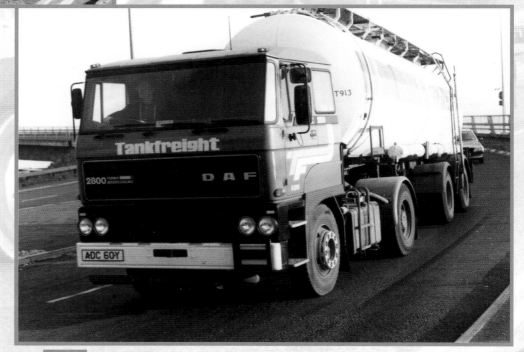

5.12 *NFC subsidiary Tankfreight ran a nationwide tanker distribution fleet and also operated tank cleaning facilities under the name Tankclean and Tankfix, Tankfreight's own engineering division. The National Freight Consortium was renamed as such in 1982 when it was privatised and was formerly known as the nationalised British Road Services and, in 1969, as The National Freight Corporation.*

5.13 *A very sturdy looking Volvo N88 from Northern France hauling an equally tough looking tanker. The N88 was manufactured between 1964 and 1973 and had the TD100 9.6 litre engine, and was part of the revised 'System 8' range which included the F86 and F88.*

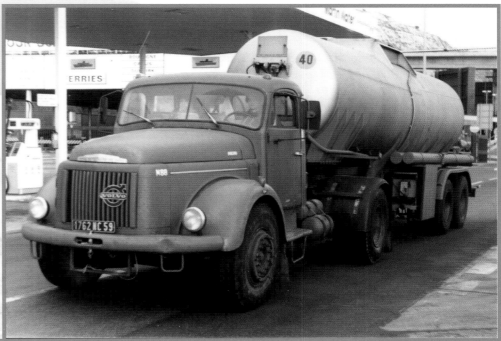

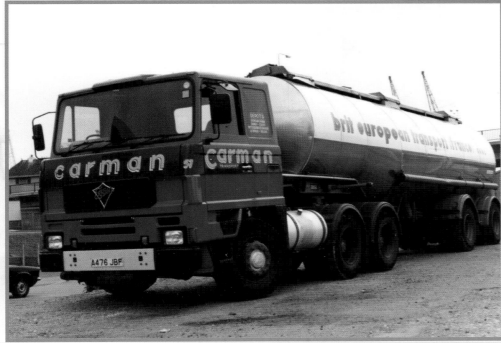

5.14 *A 1983–84 Foden 4000 Series of Brit European subsidiary Carman Transport. Foden were bought by The Paccar Company in 1980 who also owned Kenworth and Peterbilt in the U.S.A.*

5.15 *Formed in 1976, SAMAS was set up in Bradford, Yorkshire as a bulk liquid forwarder using the names of daughters Samantha and Michaela, and run by husband and wife team Mike and Pat McClelland. In the early eighties they took the plunge and invested in two Scania tractor units and tank trailers. Disappointed with dealer back up, they soon moved over to M.A.N. F90s, and listed amongst their clients BP, ICI, ESSO and Polymers.*

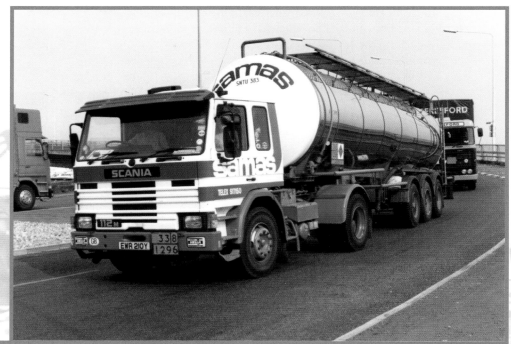

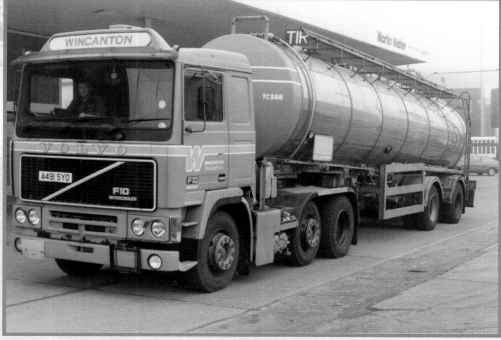

5.16 *Nationwide company Wincanton Transport also had a sister company Wincanton Tankers of Sherborne, Dorset. The tank manufacturer specialised in stainless steel tankers and supplied Wincanton Transport with lightweight trailers. In one instance recorded, it built a milk tanker with a payload of 25.3 tonne, having an unladen weight of 6560kg. This gave it a 1000kg advantage over comparable tankers of the time.*

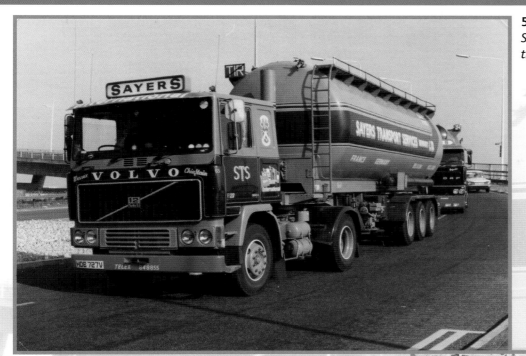

5.17 *A gorgeous Volvo F12 of Newbury based Sayers Transport. Sayers mostly remained dedicated to the Scania marque but a DAF in their fleet is seen following up behind the Volvo on Jubilee Way, Dover.*

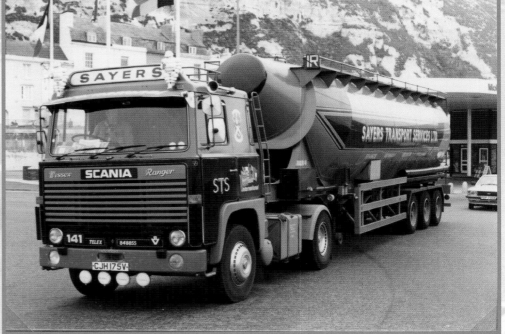

5.18 *Another great looking Sayers vehicle, a Scania 141 Wessex Ranger, exiting Dover Docks with bulk tanker. Complete with Michelin men and coach style wheel trims, the smart livery suits this combination well.*

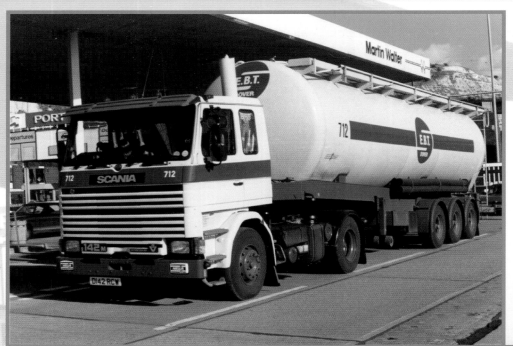

5.19 *In 1983 Karl Schmidt opened his first subsidiary company, European Bulk Transport (E.B.T.), in Dover, later known simply as Schmidt UK. A further depot was opened in 2008 at St. Helens near Liverpool and, as this proved so successful for Schmidt of Heilbronn, it closed the Dover operation in 2012.*

5.20 *First seen on a stand at the 1980 Commercial Vehicle Show in a cream livery with Eagle motifs and stripes, this White Road Commander was owned, when new, by Jonathon Deane Transport and ran with a tilt trailer. Fitted with a Caterpillar 280 engine and nine speed Fuller gearbox, when it was around a year old it ended up on its side. Locks bought the truck and repainted it in their colours but kept the eagles and stripes, and ran it on continental work. It was reputed to be very uncomfortable to drive but extremely lightweight, although the gear box and back axle were not 'man enough for the job'. Eventually Locks removed the Windstreamer roof as it persistently leaked and returned it to a flat roof version. Locks were White Trucks dealers and ran two other Road Commanders, but RHD models.*

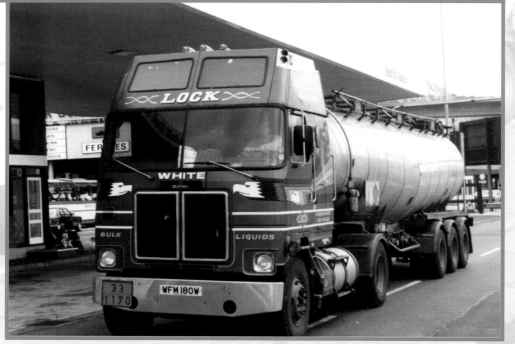

6

Tilts and Curtains

6.1 *Luckily David kept his camera at the ready when on holiday and managed to snap this fantastic picture of a Steyr as it crossed a railway line in Austria on a very damp day.*

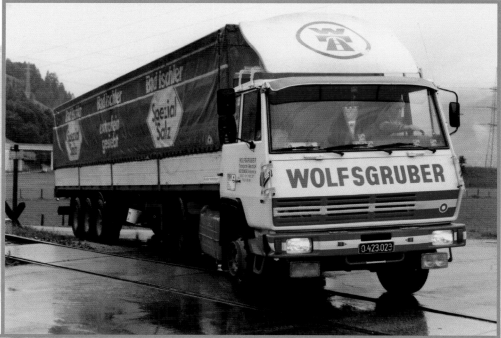

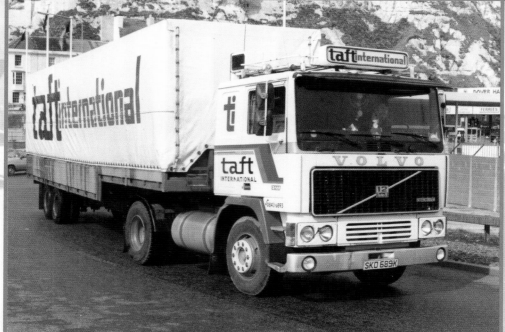

6.2 *Established in 1974 by Robin and Jacky Taft. In 1988, after training in other aspects of transport, including ferry transport, clearance agents and overseas transport, they were joined by son Richard and daughter Alison, making it a truly family affair. From being one of the leading international air freight hauliers the company has gone on to fresh produce transport with refrigerated trailers.*

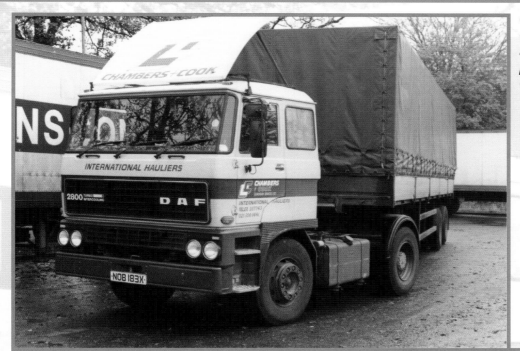

6.3 *Formed in 1925, Birmingham based international haulier Chambers and Cook now boast an impressive portfolio including air and sea freight, freight forwarding and are a member of a nationwide pallet network. With its tandem axle tilt trailer this DAF 2800 rests at Gate services on the A2.*

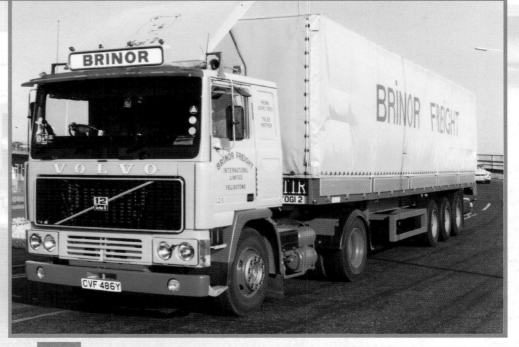

6.4 *Formed by Brian Stribbling, Brinor was an amalgamation of his and his wife Nora's names. He had an office in Felixstowe and an 'O' Licence for 15 trucks and 20 trailers in 1989. Bob Carter of Trans UK fame used to maintain the vehicles for Brian. Manfred Bahr from Germany came to live with Brian and Nora and set up a business in their spare bedroom, calling his company Brinor Services, and when Brian retired he sold Manfred his business. The trucks had Yogi written on them and a picture of Yogi Bear as it was a play on words of the name Bahr.*

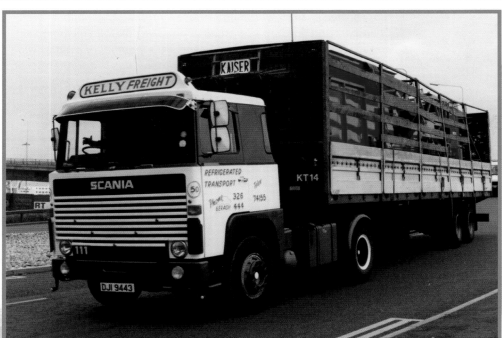

6.5 *Kelly Freight of Beragh, near Omagh, Co.Tyrone, Northern Ireland had a fleet of very smart Scania 1 series. This neat 141 is pulling a stripped Kaiser tandem axle tilt trailer demonstrating what the trailers looked like without their canvas covering.*

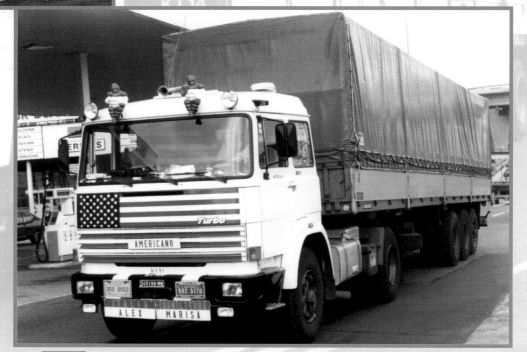

6.6 *Although the words on the front of this Fiat 190.30 advertise the fact the truck runs a service between Italy and England there is no doubt as to where the driver would rather be! As is common with Italian trailers, this one has a steering rear axle.*

6.7 *It was hard to know what category to put this Fiat 110 into, but as it has a canvas covering with tilt style fastenings I decided it would fit into this one.*

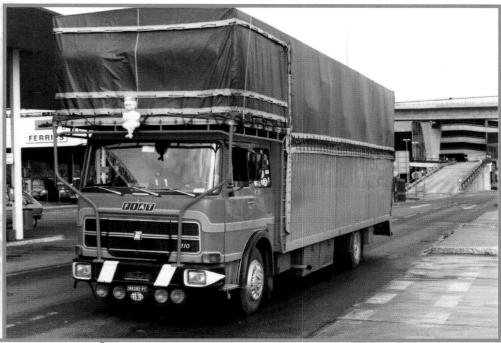

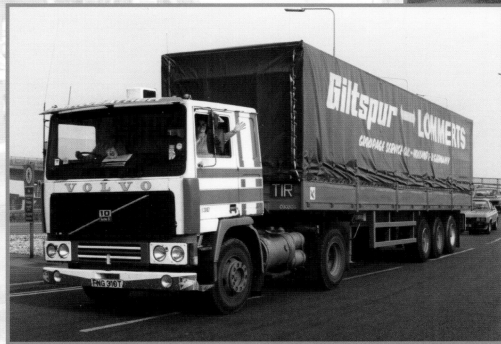

6.8 *A cheery wave hello! John Fairweather was based in Great Yarmouth and started up as an owner driver in 1971. He built his fleet up and ended up running 44 trucks. His worked covered the UK, Europe and even the Middle East for a time. His customer portfolio included the likes of British Gas, Amoco, Sanyo and Norfolk Line. The F10 is seen here pulling a Dutch trailer of Lommerts who were bought by the Harry Vos Group, also from Holland.*

6.9 *A lovely looking Volvo F12 Globetrotter of Spearings from Ashford, Kent, but the sight of the trailer makes me shudder! Any driver who has had the misfortune to have to strip a tilt trailer down, especially in bad weather, and then attempt to put it back together again would have rejoiced along with me when the humble curtainsider trailer was invented!*

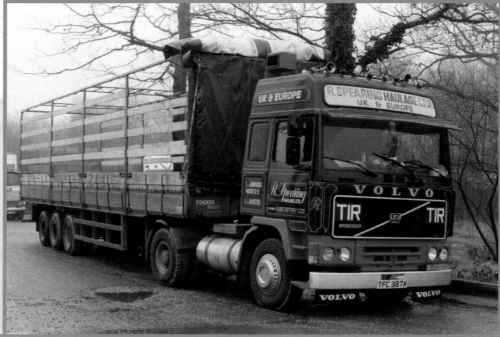

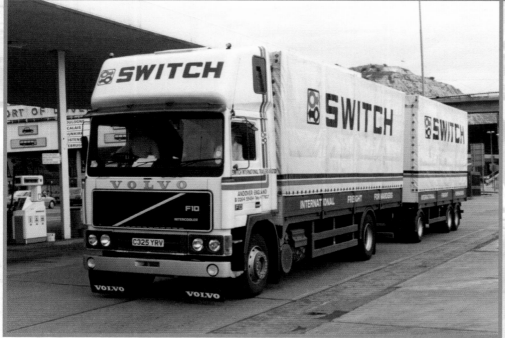

6.10 *Switch of Andover bought this high load volume drawbar to extend its Netherlands and West German operation. The day cab with occasional bunk was fitted with a cab top sleeper pod which maximised the permitted body length and gave a total load volume of 96 cubic metres. Switch supplied the GRP insulated roof extension made by Estepe in Heesch, Holland, and the Volvo dealer Princes Commercials in Southampton fitted it.*

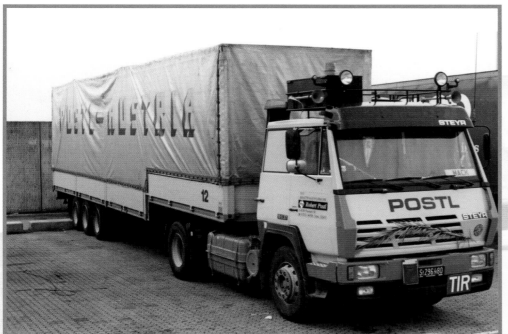

6.11 *A Steyr from Austrian firm Robert Postl at rest in Dover truckstop. The mementos in the window suggest Spain was a regular destination but the palm tree leaf on the grill was a symbol of truckers returning from the Middle East. Along with the practical roof rack storage box this indicates this may be so, or possibly the truck transits Spain to go to Morocco, we may never know.*

6.12 *'Mule Train' was a Volvo F12 owned by East Anglian haulier Dick Poll from Bowthorpe, Norwich and did UK traction work out of Great Yarmouth and Felixstowe for Frans Maas. It later caught fire and burnt out but was rebuilt and worked for many more years. Note that 'Mule Train' is being chased up Jubilee Way by Humphreys of London's Scania 'Cockney Sparrow'. 'Mule Train' was also affectionately known by its pet name of 'Sooty'.*

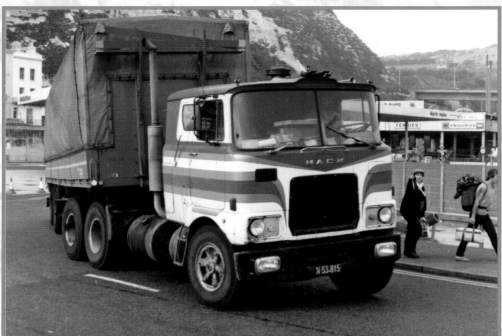

6.13 *The hitchhiker recognises a good truck when she sees one and tries to hitch a lift in this hard worked Mack F700 and tired-looking tilt trailer!*

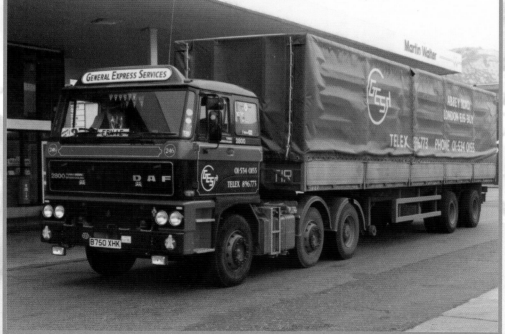

6.14 *Back in the 1980s, General Express Services did an awful lot of European work, and this smart new DAF 2800 and tilt trailer would have been returning to the Stratford yard after another trip 'over the water'. In 1988 the company moved to its present yard in Rainham, Essex and nowadays the large modern mixed fleet of trucks concentrates on UK work.*

6.15 *Showing what a completely stripped down tilt looks like, without removing the side doors, is this Volvo F89 of the Eder fleet from Kaprun, Austria. Note the sheet neatly rolled up onto the front bracket.*

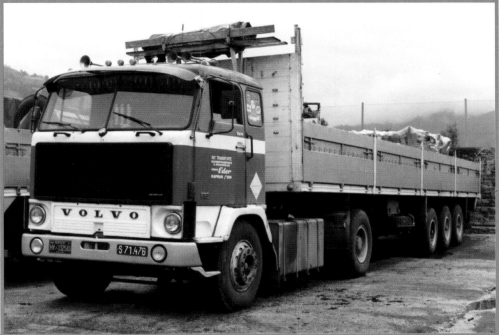

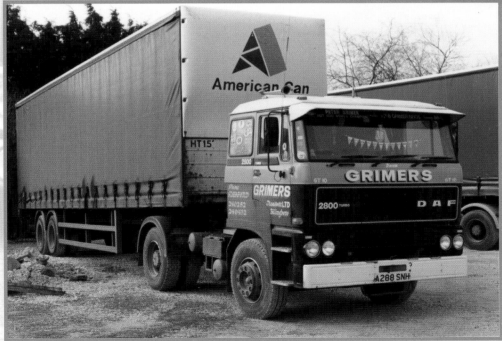

6.16 *Peter Grimer was well known not only for his smart haulage fleet but for being a champion hot rod racer and this is reflected in the sun strip on the DAF 2800 here. Peter was also a pioneer of truck racing in the UK, and also raced a M.A.N. from his haulage fleet on oval circuit events.*

6.17 *Brian and his brother, Rob Cowan started a haulage company in 1974, with Rob subsequently leaving to become an owner driver. Brian carried the name of Cowan Brothers on and operated out of Russell Davies old yard in Hodgkinson Road, Felixstowe. The company ceased trading after 25 years in business in March 1999. Newell & Wright of Sheffield took some of the vehicles and staff over, and the Cowan name was revived for a time by son Ben.*

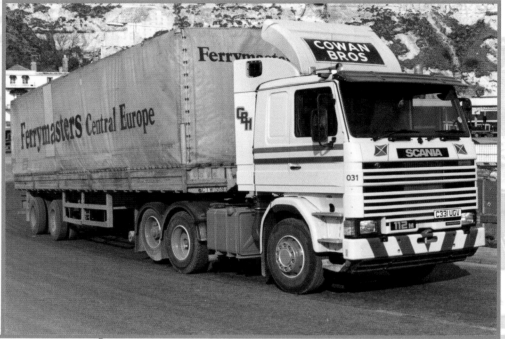

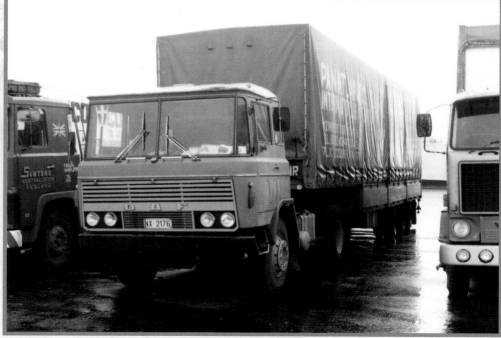

6.18 *Looking very inadequate hooked up to its step frame super cube trailer is this Greek DAF 2600 with a split screen windscreen.*

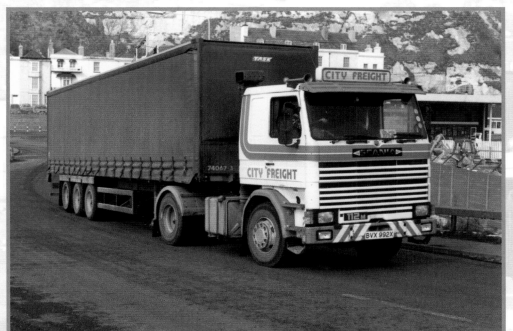

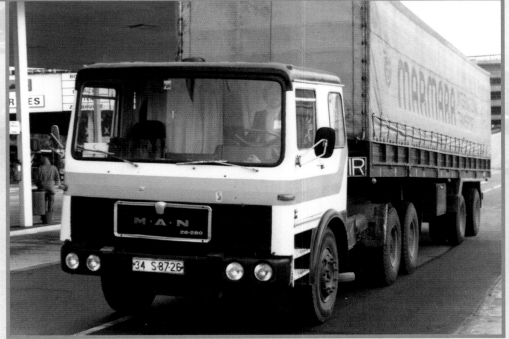

6.19 *Set up with three trucks in 1979, Milton Keynes-based transport giant City Logistics went into administration in January 2002 with over 1000 trucks and several offshoot companies. Started as City Freight in Bletchley, when the company moved to Northfield, Milton Keynes it became City Transport. The company's trailers carried the slogan 'Driven By Our Customers', a reference to the truck and trailer rental side of the business.*

6.20 *M.A.N. Turkiye A.S was the first M.A.N. production plant outside of Germany and commenced operations in 1966. Over the years the Turkish factory has produced some unusual looking M.A.N. trucks unique to Turkey, and this 26.280 from Istanbul is a prime example.*

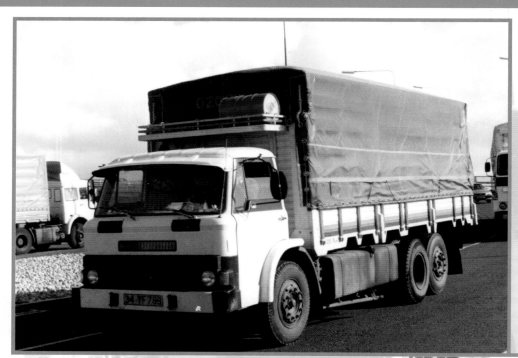

6.21 *Again from Istanbul, an even more unusual sight in the UK is this Ford D Series 'Tonka'. Of note is the steering tag axle, the large fuel tank, the traditional Turkish 'Tonka' bodywork, sunvisor, water barrel on the rack but most importantly the fact the driver has travelled from Turkey with no sleeper cab!*

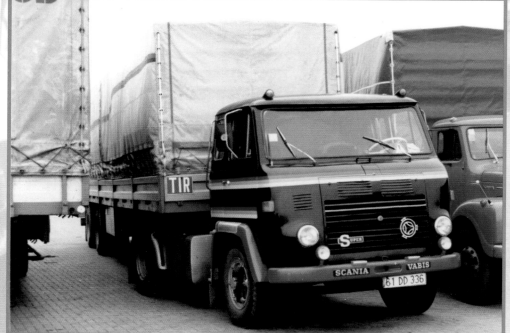

6.22 *Parked in Dover Truckstop, was this beautiful Scania Vabis LB76 Super. Dated to between 1963 and 1968 it is fitted with a very uncommon grill for that truck.*

6.23 *Next to the sleeper cabbed LB75 was this equally impressive Scania Vabis L110, also from Turkey. Another veteran truck, it is important to remember this driver has arrived in England, some 3000 km give or take – without a sleeper cab.*

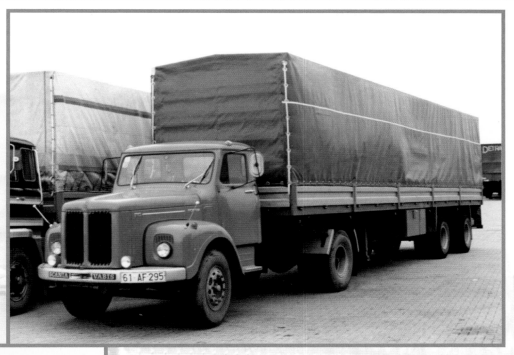

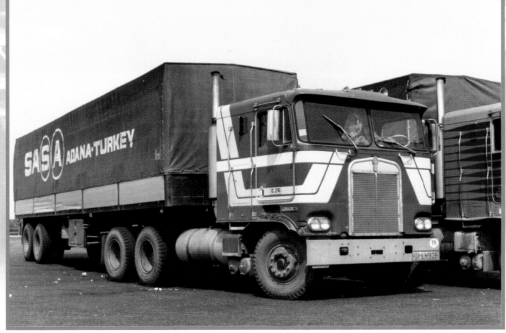

6.24 *SASA are an Adana-based Polymer company and in the 80s sent large numbers of impressive American trucks with tilt trailers loaded with PET (a plastic-based raw material) to Fibrenyle chemical company in the Suffolk town of Beccles. SASA operated 95 Kenworths, 25 Whites and five Mitsubishis, the latter being bought in kit form and assembled in Turkey.*

6.25 *Lassa Tyres are made by BRISA which is a joint venture between the Bridgestone Corporation of Japan and The Sabanci Group of Turkey. They have been in production since 1988 with Bridgestone technology and are produced alongside Bridgestone in the manufacturing plant based in Izmit in Turkey. The Sabanci Group have the majority share in SASA, hence the similarity in logo to that on the previous Kenworth. This brightly coloured Kenworth K100 COE is also registered in Adana.*

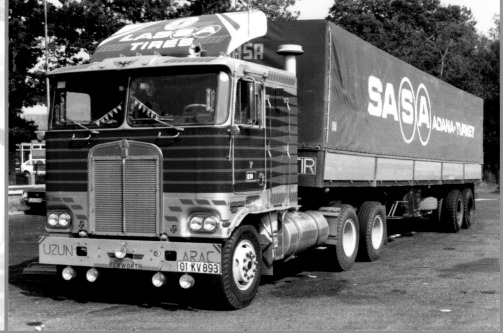

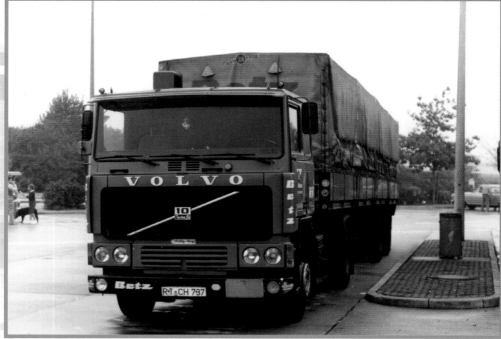

6.26 *Willi Betz has been in road haulage since the early post war years, and started with a decommissioned army truck carting groceries, building supplies, and coal, essential services in the years of reconstruction of Germany. Betz was an early player in the Middle East Transport boom, and established bases in most European countries. This Volvo F10 with tandem axle tilt trailer was based at the headquarters at Reutlingen.*

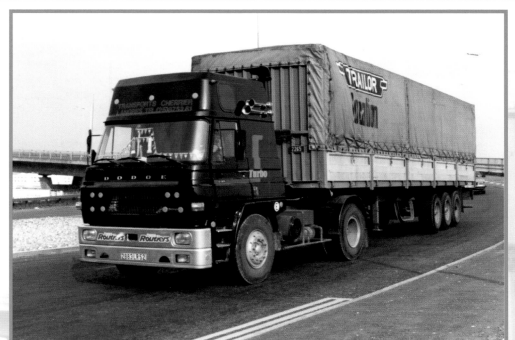

6.27 *In 1967, Barreiros in Madrid were bought by Chrysler and renamed Chrysler Espana when the Barreiros name was replaced by Dodge. In the 1970s, Dodge UK imported the 'Spanish Dodge' as they became known, designated the R38, until 1982 when the model was dropped. In the 1970s Chrysler, however, suffered financial losses in their European operations and sold out to the Peugeot-Citroen group in 1978, with Chrysler in the UK being renamed Talbot and the Dunstable based truck operation being renamed Karrier Motors. A few years later, Peugeot sold Karrier to Renault and the Dodge name was phased out. This French owned 'Spanish Dodge' features a custom made high roof and cab extension.*

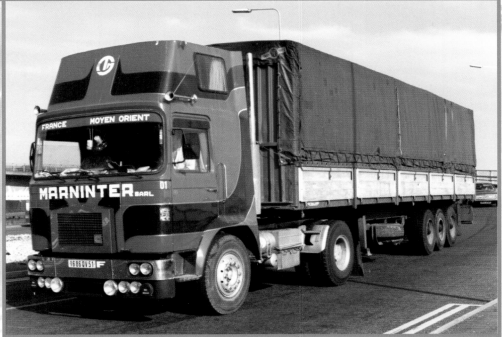

6.28 *This truck is a real mystery machine. Looking like it is based on a M.A.N. built cab it has been extensively modified with a high roof and cab extension with moulded in fairings and mudguards, custom bumper and a custom made radiator grill. Confusingly, and perhaps intentionally, it has a Cummins engine badge on the new grill. The sun strip declares the French truck from the Marne region as travelling from France to the Middle East.*

6.29 FAP was founded in 1951 in Yugoslavia and manufactured medium weight Austrian Saurer trucks under licence, and passenger vehicles. These developed into a line of trucks and buses powered by Leyland or Perkins engines, with normal control Saurer cabs and forward control Italian OM cabs. Chassis-less passenger models were sold as FAP Sanos and in 1972 the licence building agreement with Saurer was replaced by one with Daimler Benz which led to the use of Mercedes Benz cabs. This worn looking FAP exiting Dover docks with tandem axle step frame trailer uses a SK cab and is badged as having a Sanos Diesel engine.

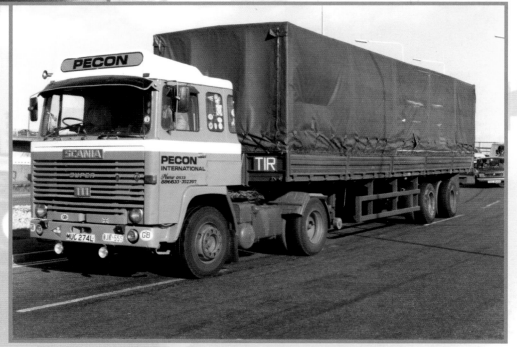

6.30 A Scania 111 with an aftermarket sleeper cab conversion, possibly by Locomotors of Andover. The giveaway is the fact the wheel arches do not reach the rear of the sleeper, and there is an additional side window fitted to the sleeper section.

6.31 *A Mercedes V10 320hp powered Hanomag Henschel from Switzerland with grubby looking tri-axle tilt. The driver looks remarkably cheerful seeing as he has driven from Basel in a day cabbed unit.*

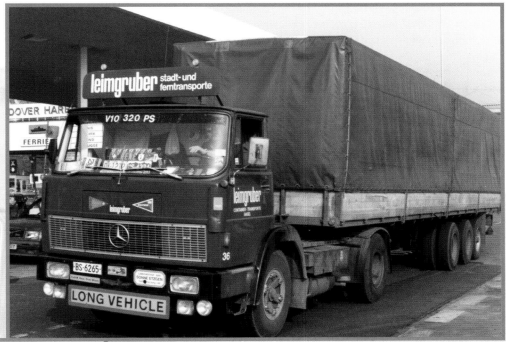

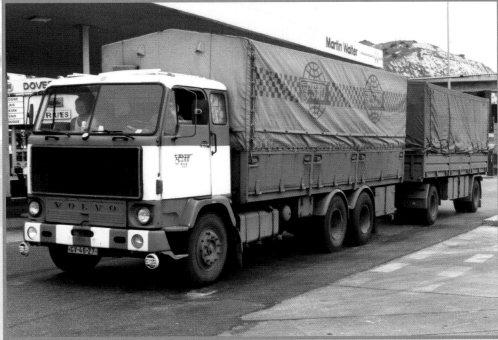

6.32 *A robust looking Volvo F88 drawbar from the Czechoslovakian state owned company CSAD from Brno. In the 80s, cross European transport was much more complicated than today with large queues at border crossings, particularly from the East.*

6.33 Mike Taylor started working for the famous Kent-based Astran in the mid 1980s, collecting their trailers from the ports and tipping and reloading them in the UK. To begin with, he worked from Astran's Middle East Freight terminal at Addington where he installed a mobile crane, so large packing cases and machinery could be transhipped. He was also charged with returning any hired trailers to their owners and here his Scania 110 has picked up a typical returning Middle East tilt trailer with a 40ft container shoehorned into it.

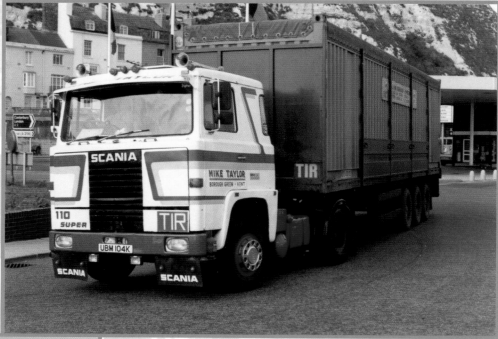

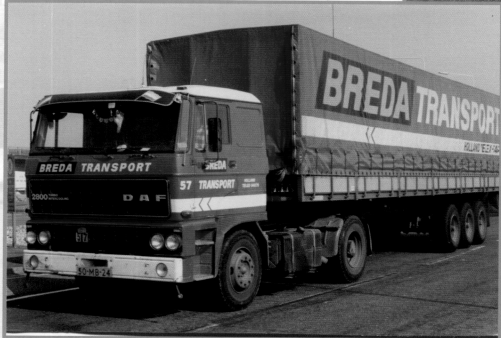

6.34 Breda Transport from Holland ran a large fleet on international work and will be remembered in more recent times for their low ride trucks used on the transport of textiles to and from Morocco, as well as traffic between Russia, Belarus, Ukraine and Romania. When Breda went bankrupt, rival Belgian firm Maes took over much of their business.

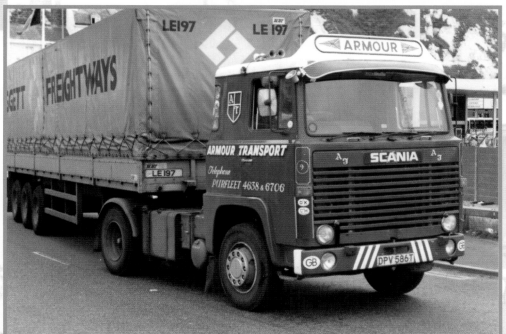

6.35 Phil Armour started as an owner driver when he purchased a second hand Leyland Super Comet 16 ton flat-bed in June 1974 delivering soft drinks around the country for Britvic in Chelmsford. After a year he started hauling for Procter & Gamble delivering soap powder and after five years on this work Phil had six other vehicles on the road. He then moved over to continental work and within a year he had eight vehicles running each week on European groupage runs. By 1980 Phil had 11 trucks, mostly Scania, based in Oliver Road, Grays and he branched out into container transport. In 1987 the company moved to a three acre yard on the new Purfleet Industrial Park on the A13.

6.36 W. Humphreys of London are best remembered for their brightly coloured fleet of Scania units with names such as 'Cockney Sparrow', 'Scarlett Pimpernel', 'Gay Lad' and, seen here, 'Pink Panther'. This particular truck had a starring role in an episode of TV soap Eastenders, and Humphreys trucks could be identified by the 'Cyclops Eye' chrome badge on the front grill. Incidentally, this was not the only vehicle to carry the Pink Panther name. CPV 487T was named 'The Pink Panther' and had a higher roof grafted onto it that looked like it came from a later Scania along with DAF 2800 lights, similar to that of 'Gay Lad'. Popular to common belief, CPV 487T did not come from the fleet of Russell Davies to Humphreys but belonged to A. Dowell of Woolpit and Basildon.

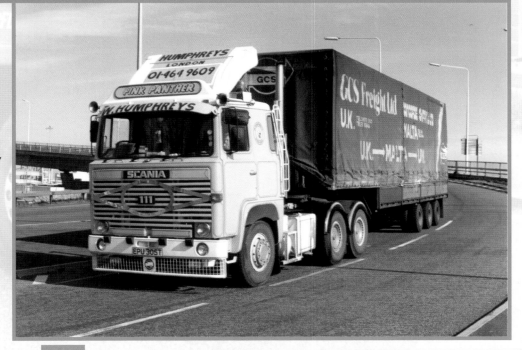

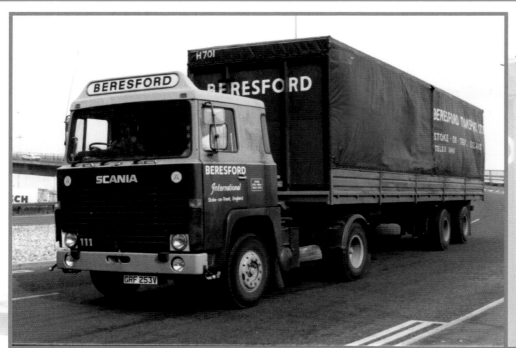

6.37 *Stoke on Trent-based Beresford Transport had a policy of buying British trucks to work in their large fleet but as long serving driver Jack Kelly was so respected he was given a choice of truck to drive. He asked for a Scania, and GRF 253V, which was a cancelled order at Scania, was put onto the road after a visit to the paint shop. Jack's main destinations were Austria and Germany although Beresford drivers could find themselves sent anywhere within Europe.*

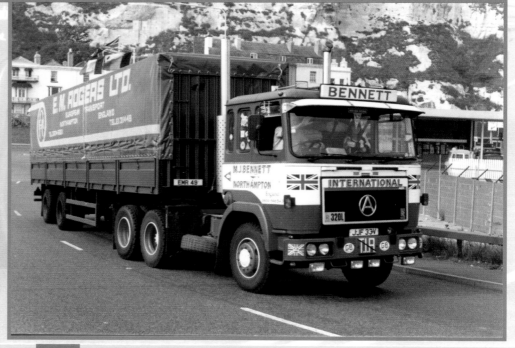

6.38 *Michael John Bennett started in road haulage in the early 1970s. 'Big Ben' as he was affectionately called (he was 6' 2") was a British stalwart and would only buy British built trucks. He bought the Seddon Atkinson 400 (JJF 33V) brand new from Vee & Inline Diesels, Daventry, Northamptonshire. It was a standard 4x2 tractor with Rolls Royce 320 and 13 speed fuller gearbox. He kept it 'standard' for a year then fancied a bit of customising. First he added a tag axle, then twin Eminox pipes, although one was an air intake and the other an exhaust stack, he just wanted them to look the same! For the first year, he hauled for EM Rogers and ACH, but then moved solely to EMR. Destinations were all over Germany and Italy and being the 'subby', Michael would often find himself shipping out on a Tuesday, so he re-loaded Italian groupage on Friday for Monday delivery in the UK.*

6.39 *Jameson (Europa) had a nationwide network of bases in the UK including Southampton, Heywood and Purfleet. Jameson was a member of the United Transport Group and had started a road groupage service to Italy as far back as 1964. In the 1970s Jameson invested heavily in 'Kangaroo' type trailers designed to be carried to Italy by railway carriage, and worked in conjunction with the Italian firm of Italmondo of Milan, the trailers arriving in the UK via the Thownsend Thoresen Le Havre-Southampton ferry, quoting times between Le Havre and Milan of 36 hours.*

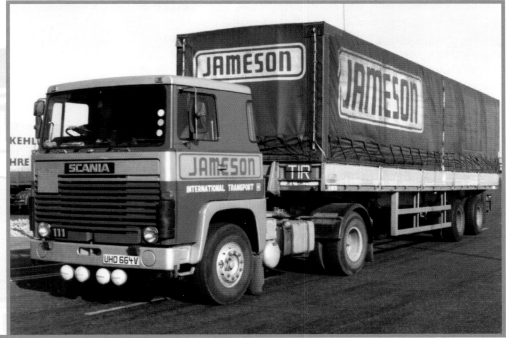

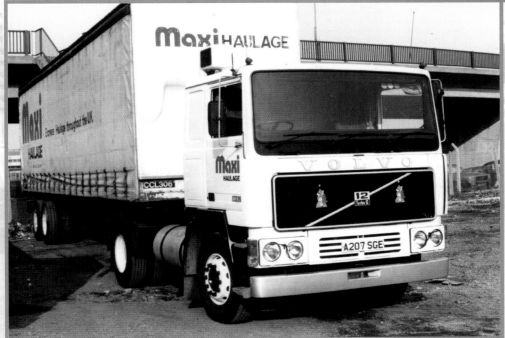

6.40 *Irvine, North Ayrshire-based Maxi Haulage, has numerous bases in the UK and Ireland. Around two thirds of Maxi's business is in logistics, including distribution of food, automotive parts and construction equipment and regularly ships unaccompanied trailers to Ireland and back. In business for over 35 years, in 1974 Maxi Haulage was incorporated and in 1976 along with sister company Caledonian Vehicle Delivery Service joined forces with Maxi Construction to form The Maxi Group of Companies.*

6.41 *'Chapter Two, The Little Trucker' is sign written on the front of this Curtis-Hillage Bedford TM, as well as advertising the fact the firm carries out UK, International and Middle East services. The spoiler suggests that the main customer of Curtis-Hillage is the Austrian firm of LKW Walter, although it is hauling a Crisp spread tandem axle tilt complete with large belly tanks which would confirm the Middle East statement.*

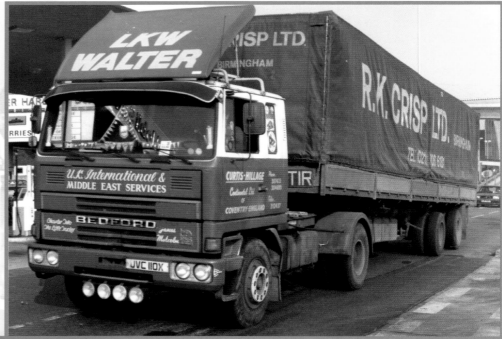

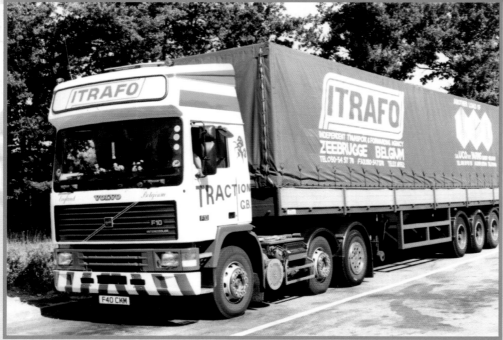

6.42 *David drove this Volvo F10 Eurotrotter himself, for Nigel Fry's Traction GB Company, on European work, and is seen here with a trailer in regular customer Itrafo of Zeebrugge livery.*

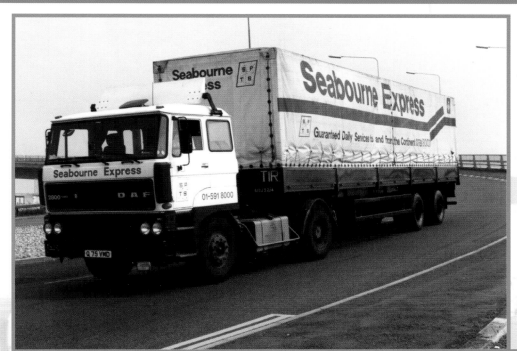

6.43 Founded in 1962 by Sir Clive Bourne from a telephone box in Shoreditch, Seabourne rapidly expanded establishing depots across Europe. In the 1980s, Seabourne acquired a freight company closely followed by an international courier express operator. The following decade Seabourne sold Seabourne Express Parcels to the giant UPS organisation, allowing it to concentrate on freight and courier work, and nowadays its portfolio includes air, road and sea freight services as well as live shellfish exports and fine art and antiques packing and handling.

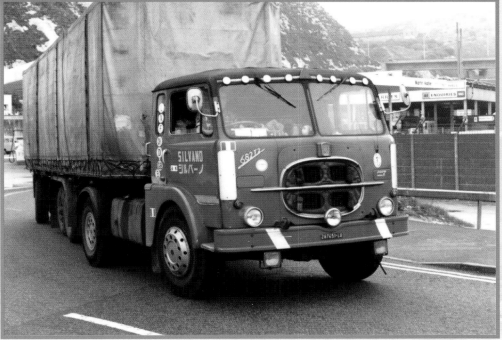

6.44 A glorious Fiat 682T2 with equally antique looking trailer, guns it out of Dover. The trailer is fitted with a rear steer axle and the other two axles seem to be set quite far forward. Usual for a truck of this age is the right hand drive layout, and the radiator has a winter cover rolled back. This truck cab design was introduced in 1952 and lasted through until the late 1960s.

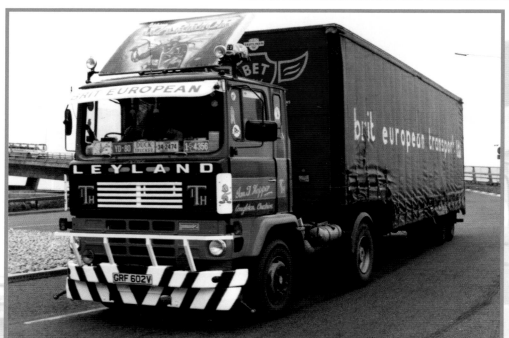

6.45 *'Viking Warrior', a Leyland Marathon 2, had been previously photographed by David in Viking Shipping livery of white and blue. Seen here repainted in Brit European livery, it retained the mural on the roof spoiler and carried the name Ian Hopper of Congleton, Cheshire.*

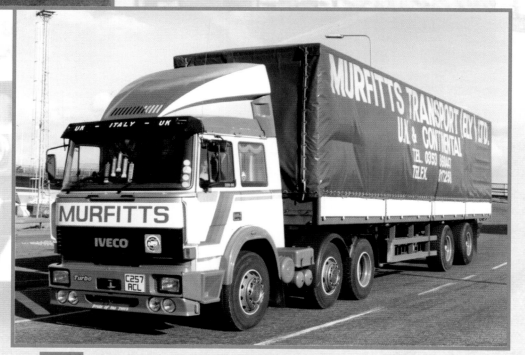

6.46 *Murfitts Transport, by the time it ceased trading, had built up a huge fleet of trucks, particularly high volume drawbar outfits and carried out pan European work for the likes of Kellogg's. Founded by Mick Murfitt, this Iveco 220.30 twin steer unit pulls a tandem axle tilt that bears the company's origins of Ely, Cambridgeshire. Although Murfitts operated many makes of trucks, Iveco always had a presence on the fleet.*

6.47 *A lovely picture of a Volvo F12 of A One Transport in the snow. A One had their headquarters at Gelderd Road in Leeds and in the company's early days did a lot of haulage to Italy. A lot of the work was from International Tractors from Doncaster and they had depots at South Mimms, Bradford and Glasgow.*

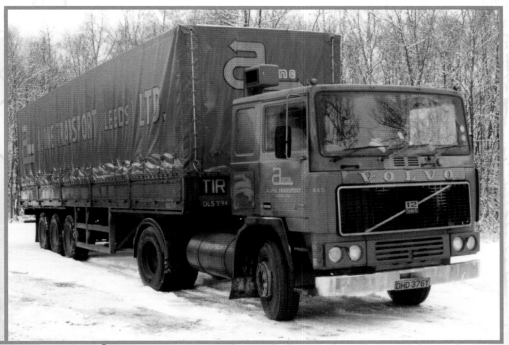

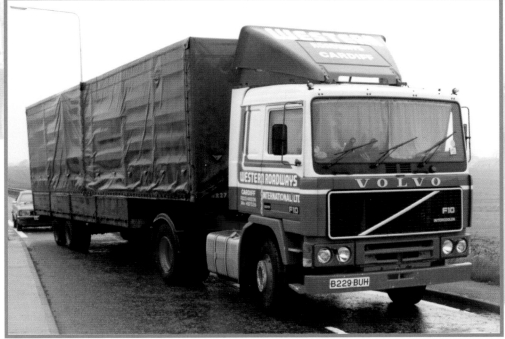

6.48 *Western Roadways (International) Ltd of Cardiff were a branch of the Swains of Stretton transport concern, hence the livery identical to Swains. Driver Steve Dawson worked for them out of a depot in Bristol and drove this truck between 1985 and 1987. The driver who took it over from Steve managed to crash it as he descended from Mont Blanc and as the story goes, the blue paint can still be seen today on the concrete wall he hit.*

6.49 Ernie Felgate always had a good working relationship with giant Dutch freight forwarder Frans Maas. Felgate Services were based at Barking in the days of this photograph and Frans Maas had a depot there too having moved from Stratford. Russell Davies had bought Ernie's company and fleet of over 20 trucks in 1982 and Ernie had gone to work for Brain Haulage, marrying Charlie Brain's daughter, Jean. After two years, Ernie started Felgate Services Ltd and did traction work for Merzario, a connection through Brain Haulage who worked for the Italian firm too, and Frans Maas. In January 2001 when based at Truckworld in West Thurrock, Felgate Services was bought by Unitruc of Shoeburyness, and the Felgate name disappeared.

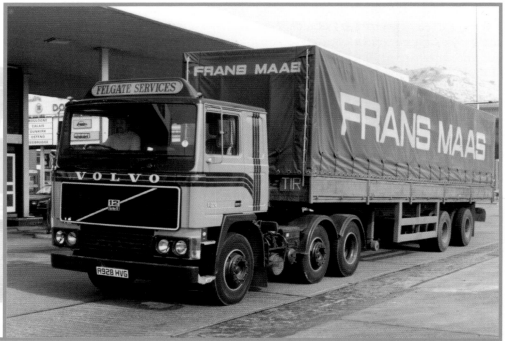

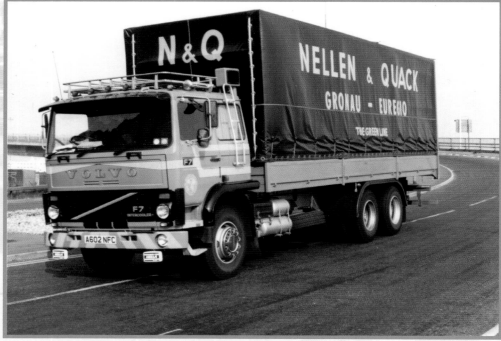

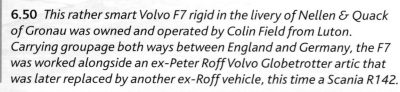

6.50 This rather smart Volvo F7 rigid in the livery of Nellen & Quack of Gronau was owned and operated by Colin Field from Luton. Carrying groupage both ways between England and Germany, the F7 was worked alongside an ex-Peter Roff Volvo Globetrotter artic that was later replaced by another ex-Roff vehicle, this time a Scania R142.

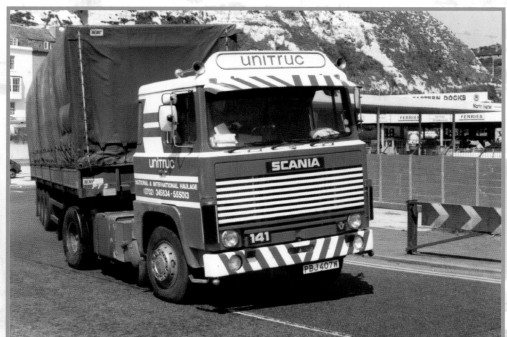

6.51 In 1978 Richard Horsfall started up his own transport business with a Transit van with Luton bodywork carrying airfreight and groupage. In those days, Southend airport was used by international vehicles to clear customs, and goods stored in the bonded warehouses plus airfreight kept Richard, then trading as RKH Haulage, very busy. Now business for the Shoeburyness based company is divided between general and express European groupage, specialist car transport, container delivery, and contract distribution. In January 2001, long established international haulier Felgate Services was acquired. After shedding Felgate's poor business, their more successful contracts were integrated into the Unitruc operation thus expanding his European coverage and capabilities. The traditional livery of red with white pin striping and lettering was changed in 2006 to white cabs with red trim and lettering.

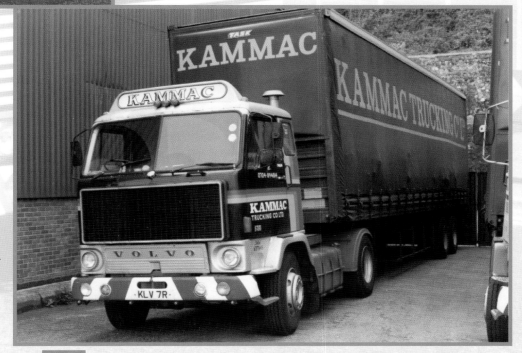

6.52 Kammac was the name given to the company first set up by Brian Kamel and his wife in the late 1970s, the name derived from Brian's surname, and the first three letters of his wife's maiden name – MacDonald. They originally started as fruit and vegetable hauliers around West Lancashire, and their first yard was at Scarisbrick near Southport. Kammac won a major contract with Nacanco at Skelmersdale, which saw the storage and distribution of empty cans to drinks manufacturers across the UK. In the early days Kammac used mainly second-hand F86s and F88s as seen here, pulling tall curtainsided trailers.

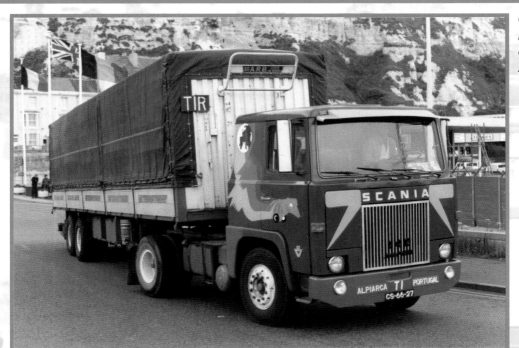

6.53 *A Portuguese Scania 140 with a distinctive paint job, chrome mirror guards, new bumper, sun visor and grill panels makes an entrance into England. The trailer is kitted out with the popular Iberian style of side lockers and water barrel.*

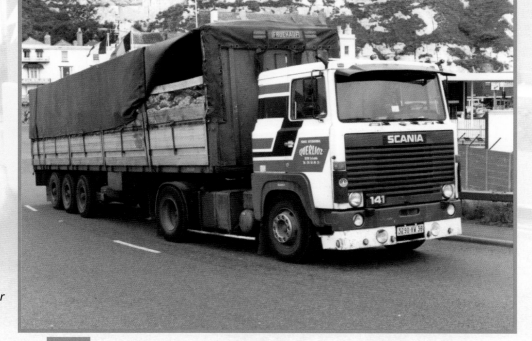

6.54 *It is unclear why the tilt cover on this Fruehauf trailer is peeled back, maybe to vent the trailer because of the full load of onions it is bringing into the UK. The French Scania 141 has had an under bumper spoiler of sorts added complete with lights, and sports the usual flimsy looking sideguards below the tank.*

6.55 *Another of David's trucks was this Iveco 190.36 Turbostar belonging to E&D Enterprises of Canterbury. Bought to work on Edwin Shirley Trucking's tour with The Rolling Stones the unit still proudly wears the EST logo as it goes about more mundane work pulling a Maenhout trailer.*

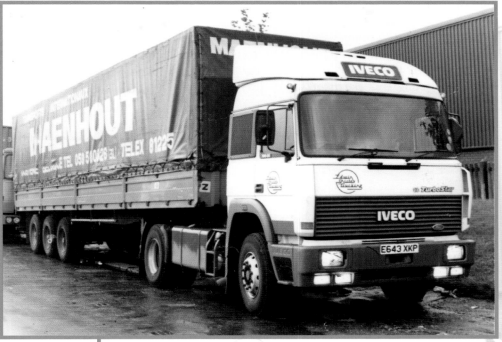

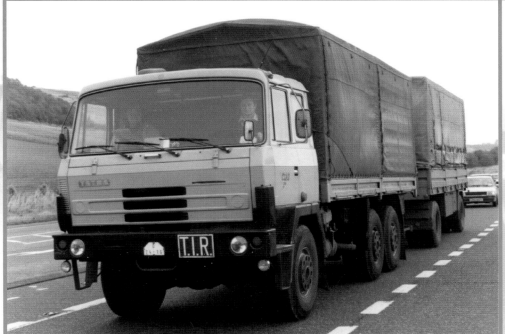

6.56 *What a tough looking combination this Tatra six-wheeled rigid and drawbar trailer looks. From the Czech state owned CSAD, the same as the earlier Volvo F88, the mirrors on the truck look miniscule, especially the one angled across the front of the cab. Rumour has it that although many East European trucks appeared to be double-manned in the past, the second driver was in fact a Communist Party official and was there to make sure the driver didn't abscond to the west, and maybe gather some useful data about the western countries visited to take to his bosses.*

6.57 *Euroroute from Northampton was tasked with the traction of Bulgarian trailers like the one in the picture. The trailers would be sailed from Bulgaria on barges into the German town of Passau, near the Austrian border, where the Euroroute trucks would collect them. They would return to England, unload their cargo and reload them with export goods, and take them back out to Passau again.*

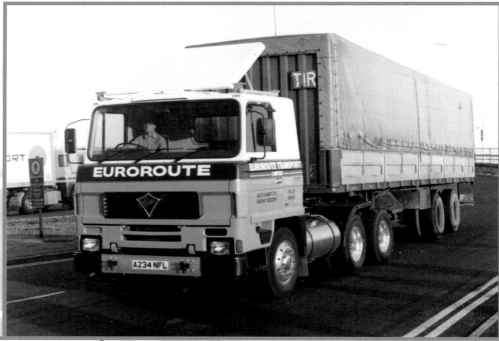

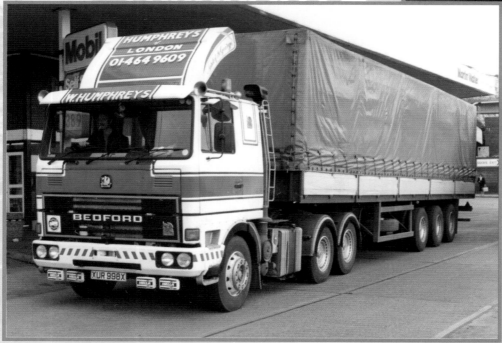

6.58 *Another Humphreys of London truck – this time a Bedford TM six wheeled unit. Bedford was owned by General Motors from 1925, and the similarities between the TM cab and that of sister company GMC were quite obvious, especially when a stylish paint job like this was applied. Note that the TM has a Scania roof spoiler fitted and wheel trims all round, even the trailer.*

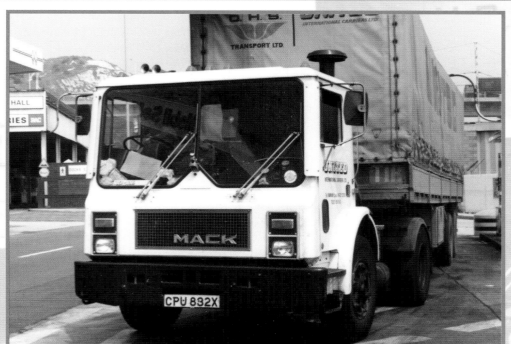

6.59 OHS Transport Ltd was formed in 1975 by Turkish owner Oran Hassan Suker and had depots in Ankara and Rainham, Essex. In the same group were a Turkish Company, Contex, and Munich based German company United Transport GmbH. In 1978 PIE's (Pacific Mountain Express) trucking side was bought, and the fleet consisted then of 125 trucks in the UK fleet made up of Macks, Volvos and Seddon Atkinsons. Middle East Transport started in 1975 and by 1976 they were covering Iran, Iraq, Saudi Arabia, Kuwait and Jordan. This urban Mack 4X2 MR Series was used to collect shipped trailers and unload them in the UK. The MR is more commonly used as a refuse truck or concrete mixer in the States.

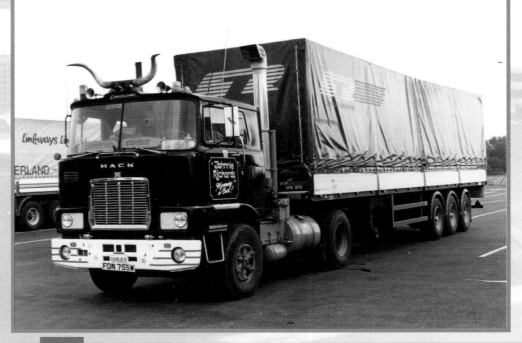

6.60 Fans of the BBC TV series 'Truckers' in the 1980s will recognise this Mack as belonging to owner driver 'Lonesome Cowboy' played by Philip Davis. The real truck was used on international haulage and is seen here wearing its TV livery, complete with BBC TV sticker in the windscreen.

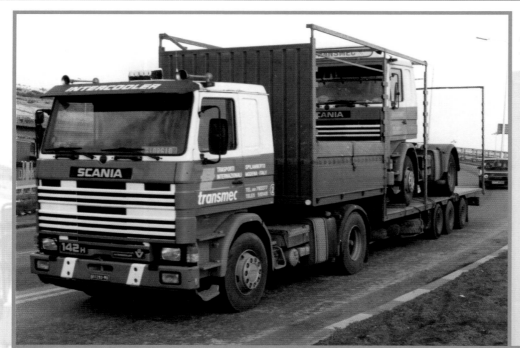

6.61 Italian firm, Transmec, was founded in 1850 by the Montecchi family and now boasts depots and offices worldwide. A UK base was set up at Thurrock and serviced a contract they had with the tractor factory at Basildon, something which the company is still involved in. At some point the company rebranded the trucks and trailers briefly with the initials of the company, Trasporti Internazionali Transmec, but thankfully this didn't last too long – work it out!

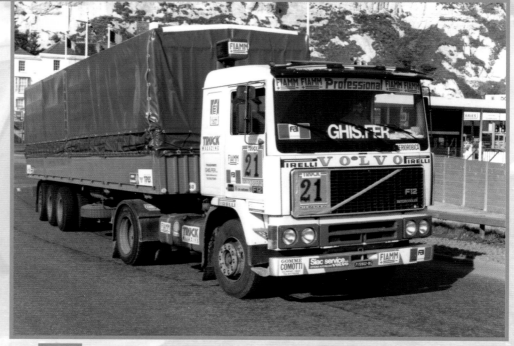

6.62 In 1984, Dhullio Ghislotti drove his Volvo F12 to the first ever British Truck Grand Prix in Donnington, unhooked his trailer, raced and won the final heat, collected his trophy, reconnected his trailer and returned to the less glamorous world of haulage. He retained the racing stickers, obviously proud of his accomplishment, and returned to Silverstone to race again. Ghislotti ran his own 14 truck business at Bariano, near Milan and began racing Alfa Romeos when he was 18. He moved on to Formula 3 and raced a truck for the first time at Spa, Belgium in 1983.

6.63 *If you search for hauliers in Carlow on the internet you come up with no fewer than 22 other names than that of Brian Kehoe. Nearby Kilkenny and Wexford boast just as many, so you have to be good to survive the competition in Ireland and Brian Kehoe is still trading today. Back in the day this was typical of one of his hard worked trucks, parked at Gate Services on the A2 in Kent.*

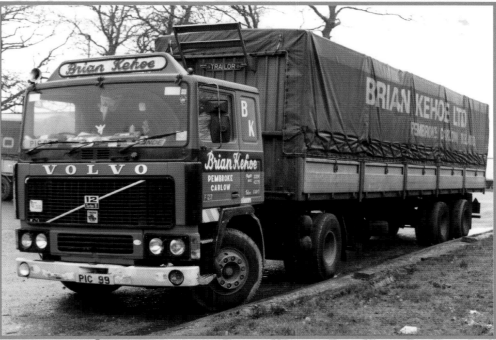

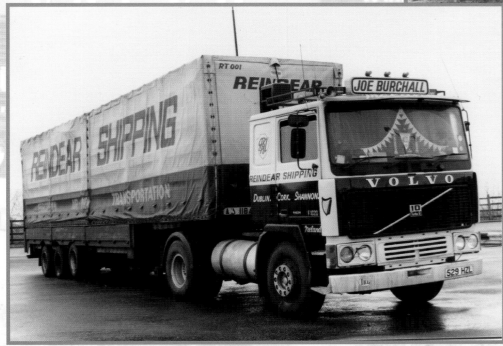

6.64 *A lovely looking outfit in Reindear Shipping colours. Joe Burchall started business at Naas, Co. Kildare in September 1984 and worked for Reindear who specialised in airfreight, freight forwarding and warehousing at Shannon airport.*

7

Tippers

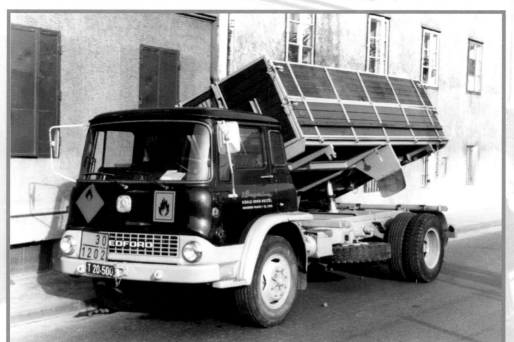

7.1 *This neat little Bedford TK was delivering coal to the cellar of a house in Austria. The clever side tipping system means the coal could be delivered with the minimum of fuss, directly to where the customer required it.*

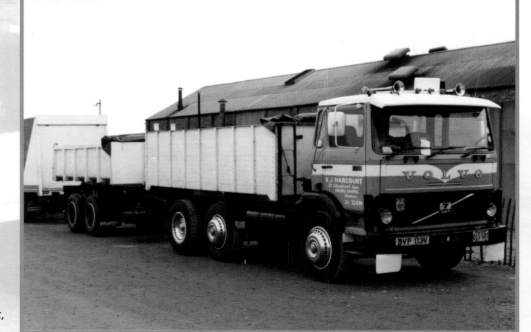

7.2 *A very unusual set up for the UK is this Volvo F7 and its tandem axle 'pup' trailer. It's not clear if the second axle on the rigid is a lift axle, a second steer or just a pusher, but it looks like a versatile outfit, seen here at the first Truck Grand Prix at Donnington in 1984.*

7.3 *Nottingham Road, Ashby-De-La-Zouch-based Moores ran a mixed fleet of trucks, from ERF B Series, Volvo F88, Atkinson Borderer and Ford Transcontinental and in the later years particularly when on the refuse work for A&J Bull they had Volvo F12s like this one, however, older drivers will also remember the Ford Traders and D Series they had in the 1960s.*

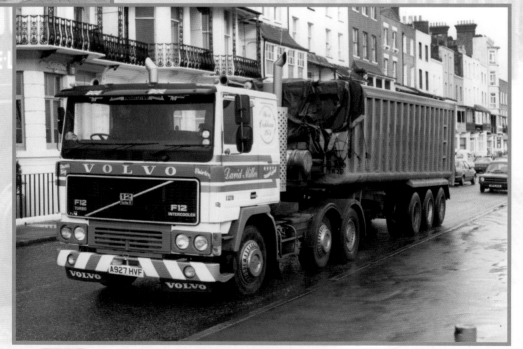

7.4 *A smart-looking Volvo F12 of David Miller driving through Ramsgate. The tipper trailer is fitted with a 'donkey engine' to power it; you can just see the fuel tank on the front of the chassis.*

136

7.5 *Fitted with the TD120 engine, this lovely Austrian Volvo F89 4X2 tipper would have been a proper little powerhouse in its day.*

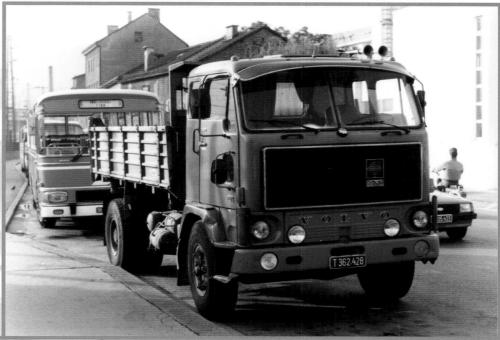

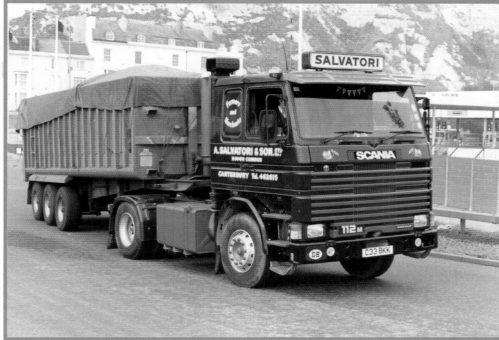

7.6 *Another company still surviving in the competitive world of haulage is that of Salvatori from Canterbury. In business for over 80 years it is still a family owned and run firm and is the UK's longest established processing fruit trader specialising in processed apples and pears.*

7.7 *A nice looking Scania R112M of R & A Young of the delightfully sounding Esh Winning, Durham. Note how the Scania trademark stripes have been worked into the colour scheme and the Viking mascot mounted on the sun visor.*

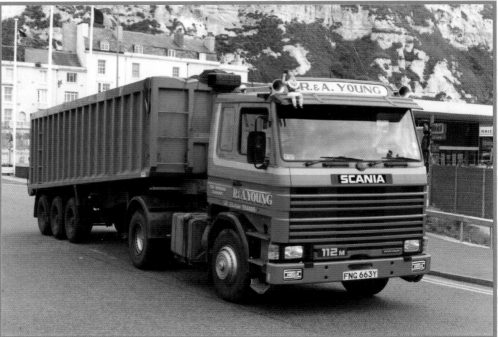

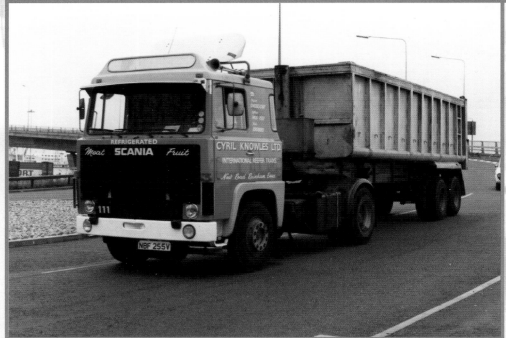

7.8 *Obviously not usually connected to the tipper if the signwriting is anything to go by is this left hand drive Scania 111 of Cyril Knowles, then of Rainham. Knowles was later known for running very smart refrigerated trucks on European haulage, and after that he had the well-known fleet of bonneted Scania 4 Series units on bulk powder tanker work. Cyril also kept horses and had a horsebox to take to events.*

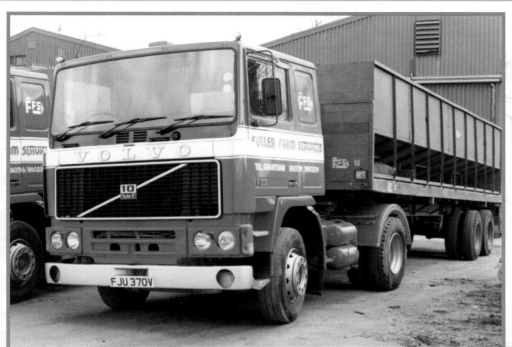

7.9 *It was difficult to know what section to put this in but I decided on tippers. The very smart looking Volvo F1017 belonging to Fuller Farm Services of Grantham is coupled to a self emptying vegetable bulker. Unloaded by a conveyor belt system, they have been known to carry the likes of dwarf beans, potatoes, onions, carrots, parsnips and even daffodil bulbs.*

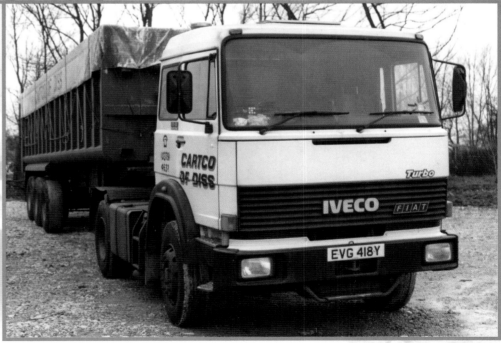

7.10 *Cartco of Diss were formed in 1978 as a bulk tipper operator who also ran a small distribution business. On 13 November 1987 Russell Davies bought the business but gradually wound up the bulk tipper side, and rapidly expanded the distribution arm and boasted customers such as Jeyes, Colman's Mustard, Robinsons Drinks, Kellogg's Cereals and Tilda Rice.*

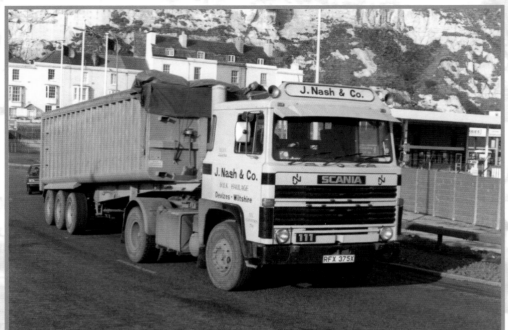

7.11 *A Dorset registered Scania 111 of J. Nash from Titchbourne Farm, The Cannings, Devizes, Wiltshire pulls out of Dover followed by a Vauxhall Viva. This 1981–82 registered truck has been fitted with air horns, a sun visor and marker lights on the grill.*

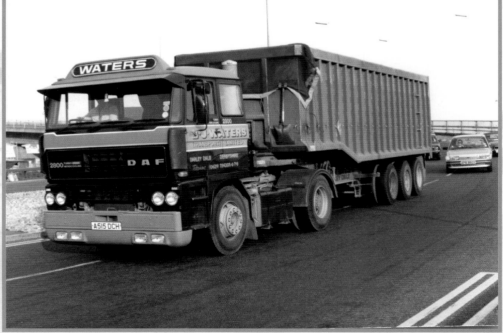

7.12 *The firm of B.J. Waters from the lovely village of Darley Dale in Derbyshire have been doing continental tipper haulage for a long time and were established as hauliers in the early 1920s. The most common commodity carried in the tippers is non-ferrous metals, but they also carry coal, plastic and marble.*

7.13 *Newton Haulage of Toddington was chosen to carry out field trials of the new truck in the Volvo range, the FL. To try to disguise the completely new shaped cab, a fake radiator grill was attached to the existing one, but it didn't really fool anyone as it looked so fake and out of place. To put people off further, non-specific number plates were used on the trucks, and it is quite surprising David was able to photograph the trial trucks at all.*

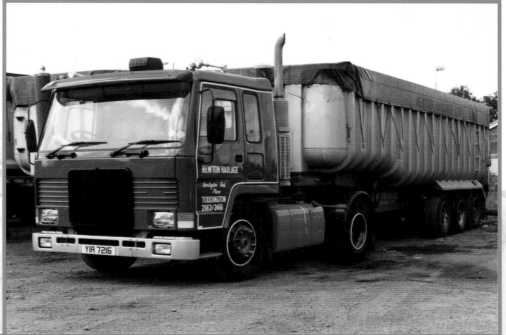

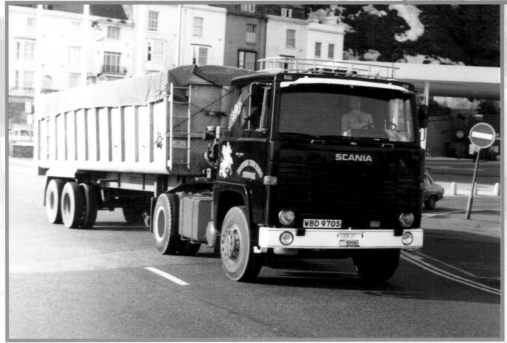

7.14 *Terry Blakesley was an owner driver and contracted to Rock and Roll giant Transam Trucking of Suffolk and went all over Europe for them, hence the LHD truck. When the rock tours were quiet, Terry subbed himself out to Cartco of Diss on bulk tipper work. The truck was called 'Giddy Up Go' and the cab sides featured a cartoon of Terry riding a horse playing a guitar with the music notes floating around the back of the cab. The cartoon was done by the Eastern Daily Press newspaper cartoonist Derrick Webb, who also painted a similar cartoon on Terry's next Scania, this time a 141.*

7.15 *Fitted with massive 'greedy boards' is this substantial looking Magirus Deutz 256 seen at the Truckstar Power Festival at Zandvoort, Holland in 1985. Note the neat fitment of the hydraulic oil tank for the tipper onto the truck chassis.*

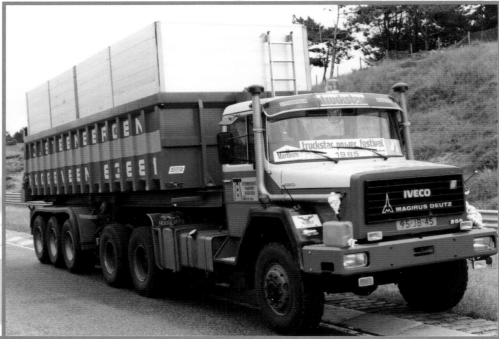

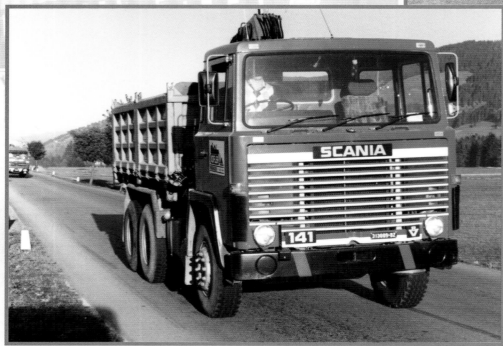

7.16 *An Italian Scania 141 6X4 rigid tipper spotted in Austria. The powerful rigid is also fitted with a crane behind the cab.*

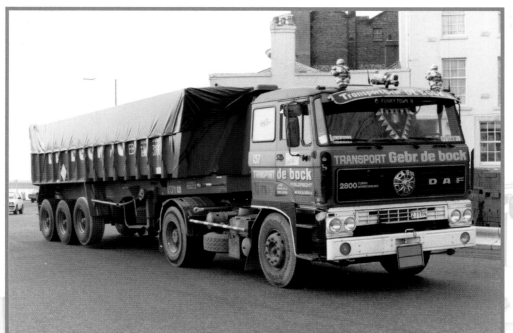

7.17 This DAF 2800 of De Bock from Kieldrecht, Belgium has a hazardous load in its tri-axle tipping trailer, but it must be light as the leading axle is lifted. The De Bock brothers are still very much in business today.

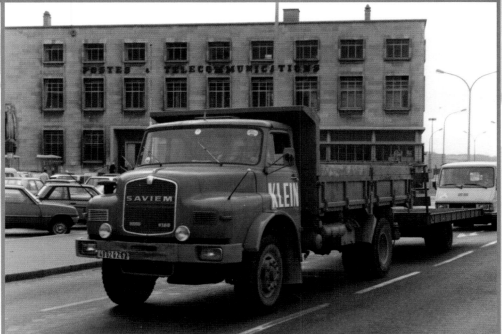

7.18 Saviem began a co-operation with M.A.N. in 1968 and the two manufacturers shared cabs and engines in their range of trucks, which is evident with this M.A.N. cabbed truck in France. The Europeans have long used rigid tippers with trailers carrying equipment such as excavators for a long time now, something that has only caught on in the UK in more recent times.

8

Low Loaders and Heavy Haulage

8.1 *A Heanor Haulage F12 carrying a NCK Pennine crane. The company originally started its journey as the Heanor Coal & Haulage Company Ltd, but following the Second World War became Heanor Haulage Company Limited, under the guidance of brothers Ken and Jack.*

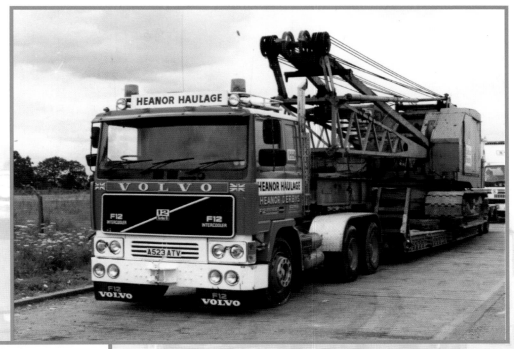

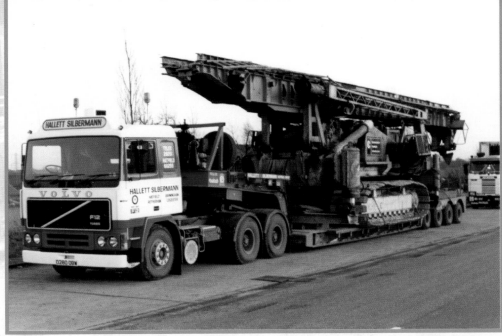

8.2 *A very heavy looking outfit on this Hallett Silberman Volvo F12 consisting of a piling rig. Hallett Silberman has been trading since 1946 and has depots at London and Birmingham and in April 2014 was sold to R. Swain & Sons of Rochester, Kent.*

8.3 *An Italian Berliet TR350 coming through Dover importing a Fiatallis excavator.*

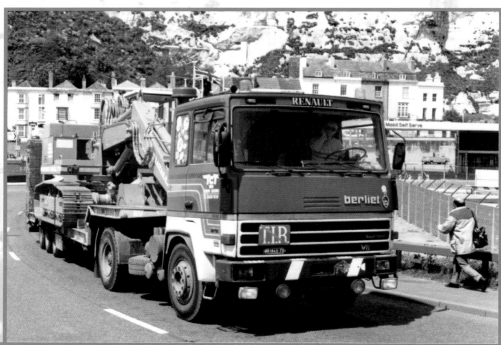

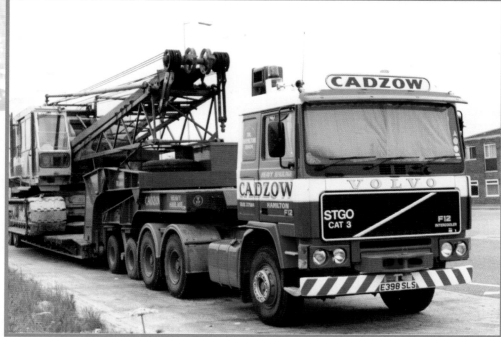

8.4 *A Cadzow Heavy Haulage of Hamilton Volvo F12 with a NCK crane, possibly a NCK Ajax but could be a NCK Andes. Note the dolly supporting the weight at the front end.*

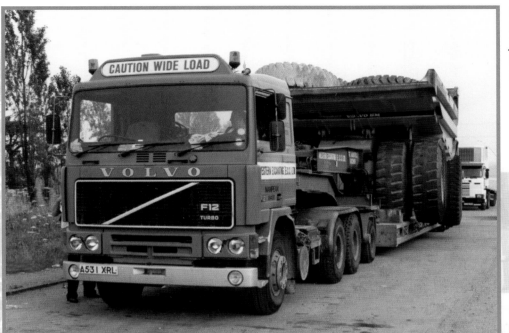

8.5 *Parts of the English China Clay Company Western Excavating (ECC) were formed for the removal of overburden and waste materials from the extraction of china clay, along with the Heavy Transport Co. Ltd. Based at the china clay mine at Nanpean in Cornwall, this Volvo F12 carries a Volvo BM rigid hauler.*

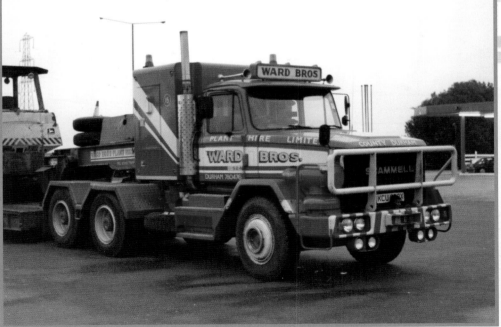

8.6 *The Scammell S24 of Ward Bros. from Durham spent around 15 years on low loader work until sold to another haulier who turned it into a rigid tipper working off road. Wards managed to buy the truck back again as they had kept in touch since selling it, and started on a full restoration project. The intention is that, when finished, it will go back into active service once more pulling low loaders.*

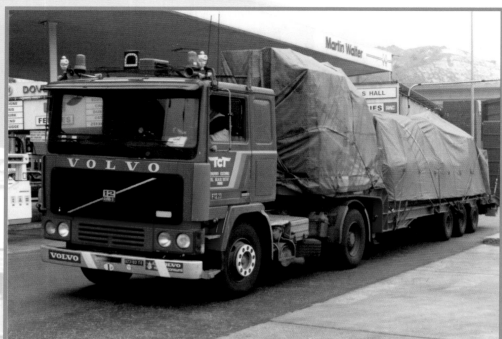

8.7 *From the same Italian company, TCT, as the Berliet this Turin based Volvo F12 pulls a medium-weight low loader with a mystery load under the sheets.*

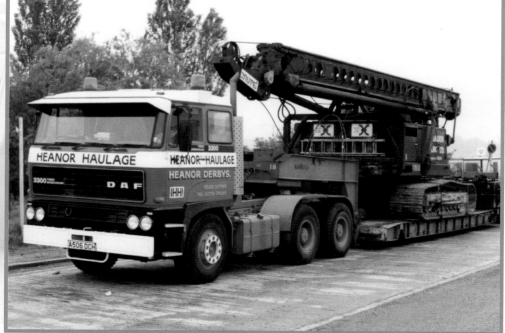

8.8 *A DAF 3300, this time of Heanor Haulage. The low loader carries a piling rig that has been converted from an excavator, either Ackerman or Banut, but it is not clear which from this photograph.*

8.9 *Looking very new at a showground is this DAF 3300 heavy haulage outfit of Lumsden's of Maidstone, with a modest Hamm road roller on the trailer.*

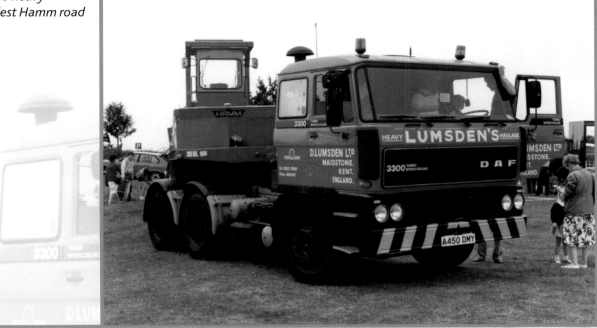

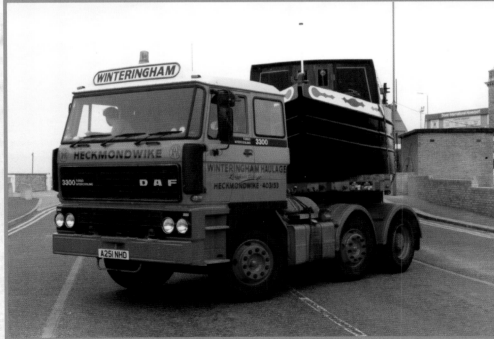

8.10 *A DAF 3300 twin steer unit from West Yorkshire, with an interesting load consisting of a canal narrow boat.*

8.11 How many axles? Seen in its home country of Austria, along with its escort vehicle, is this Felbermayr Mercedes Benz 3850. Felbermayr are a heavy haulage and lifting specialist and have their own port for transhipping loads from ships.

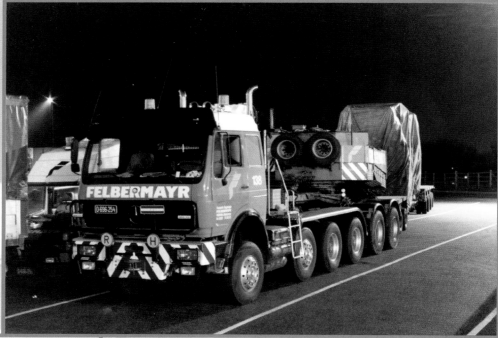

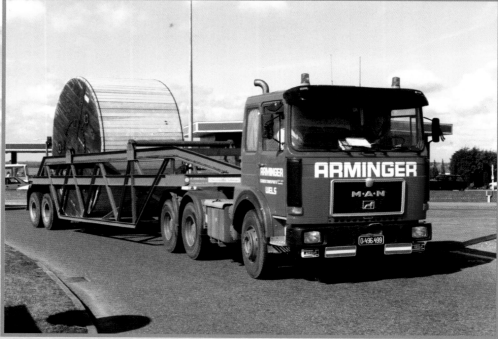

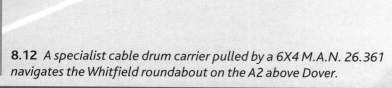

8.12 A specialist cable drum carrier pulled by a 6X4 M.A.N. 26.361 navigates the Whitfield roundabout on the A2 above Dover.

8.13 *Just one of the large and very smart fleet of Eder from Kaprun, Austria is this tidy DAF 2800 6X4 unit and low loader.*

8.14 *What a tired looking Volvo F12 this is, and looking like it may be struggling with all that weight over its drive axle. The left hand drive 4X2 is carrying a type of shunter locomotive that was supplied to the NCB and is most likely a Hunslet or Hudswell Clarke.*

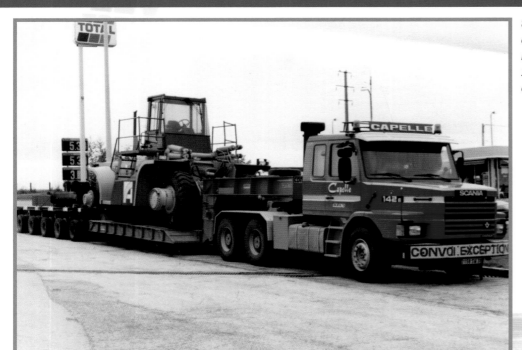

8.15 *A Scania T142E and five-axle low loader complete with container handler load makes an impressive sight at a truckstop in France. Monsieur René Capelle created a small transport company in Salles du Gardon in France in 1950 and is still trading today and has 28 depots.*

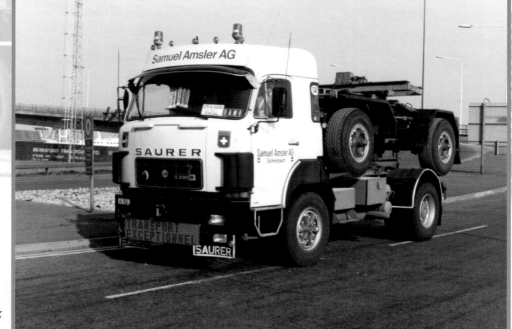

8.16 *This Swiss Saurer D330 is carrying its own dolly as there is obviously no return load available for this kind of outfit. It is designed to carry long lengths like concrete beams or railway lines, the bogie sitting under the rear of the load and being chained on. Adolf Saurer was building trucks as far back as 1903 and in 1982 Daimler-Benz took full control of the company.*

8.17 *This 1972–73 Scania 110 has suffered some damage to the nearside at some point, the broken headlight has been covered up, the door is creased and the dirt deflector broken. Its 1966 road roller load has also been in the wars with a broken back window.*

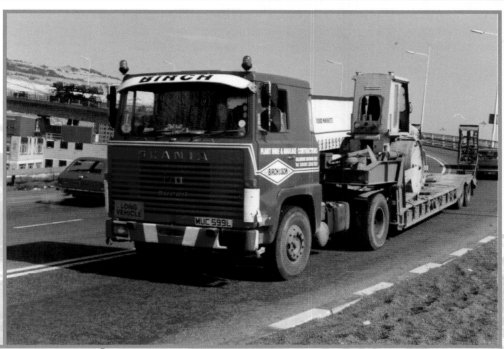

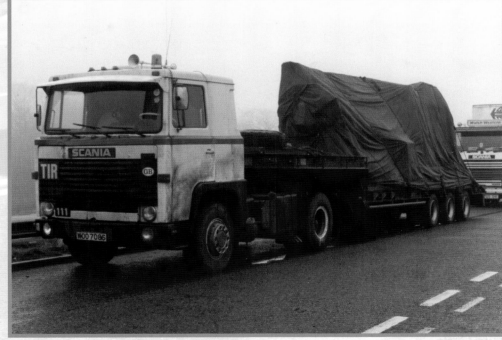

8.18 *This Scania 111 looks to be an ex-Pan Express unit according to the colour scheme. It has a neatly sheeted piece of machinery on the Broshuis low loader, and seeing as the unit dates from around 1978 the driver may be at the back of the trailer checking out what may be the future truck for him.*

8.19 *John Golding was well known for running a variety of American trucks in his heavy haulage operation. The fabulous picture is of two of John's Kenworth K100 cabover trucks with large wide loads on board.*

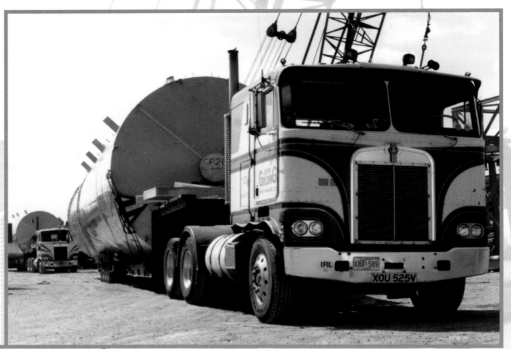

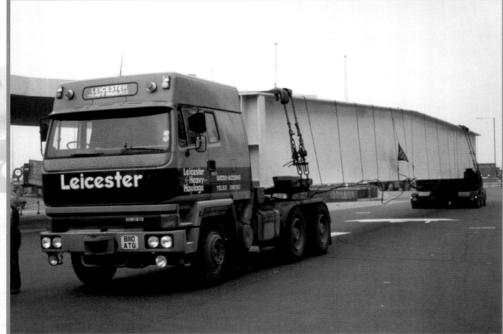

8.20 *Arriving at the port of Dover is a section of a new linkspan to be fitted at the dock. Hauled by a Scammell S26 with a high roof conversion from heavy haulage specialist, Leicester Heavy Haulage, this demonstrates how long loads such as this are supported by a dolly at the back rather than using an extendable trailer.*

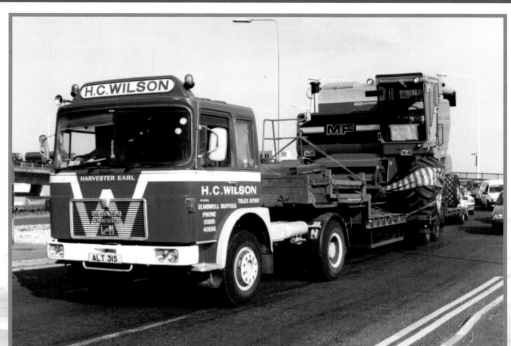

8.21 Reputable heavy hauler Wilsons only had two M.A.N. trucks in their history. ALT 31S was a 16.280 4X2 unit named 'Harvester Earl' and was bought used from truck dealer Barnards of Stowmarket who originally sold Bedfords then Mercedes. The other M.A.N. was D82 DPV which was bought new and was a rigid drawbar.

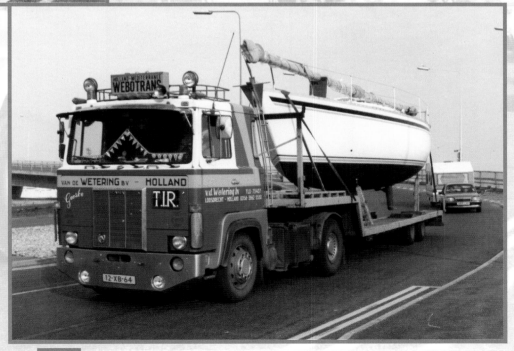

8.22 Displaying the fact that a Holland-Mediterranean service is provided is this stylish Scania with blanked out grill, deep chrome bumper and American bullet marker lights. The Van De Wettering truck is carrying a nice medium size yacht to warmer climes and is being looked at perhaps enviously by the holidaying family in the Vauxhall Cavalier behind.

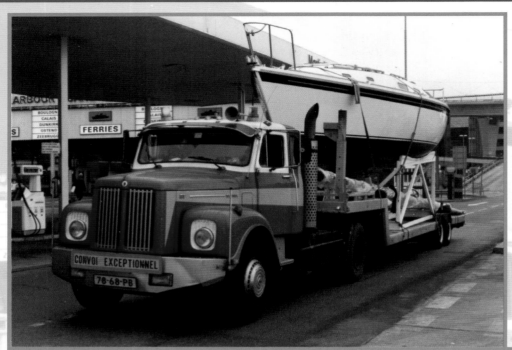

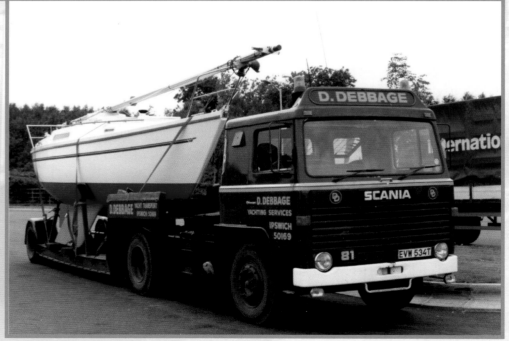

8.23 Also in Van De Wettering colours is this ageing Scania L81, again with yacht on board but this one is being brought into England. Note how the mast stows away neatly at the side of the trailer alongside the boat.

8.24 As Scania didn't offer a sleeper cab on its 81 model this has to be a conversion, although it is a neat job as the wheel arches are extended to the back of the sleeper. The unit is possibly ex-Chris Hudson, who had a lot of their green and white 81s converted into sleeper cabs.

9

Specialist and Entertainment

9.1 *This Belgian Scania T112 was photographed several times by David on its visits to England, pulling an air suspended glass trailer.*

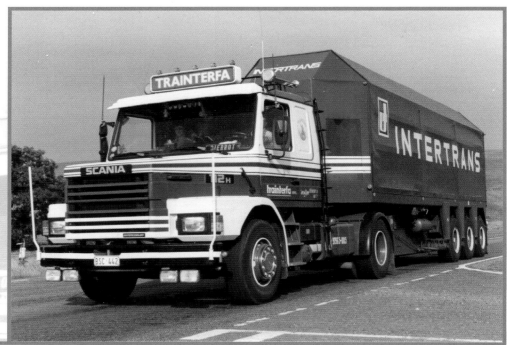

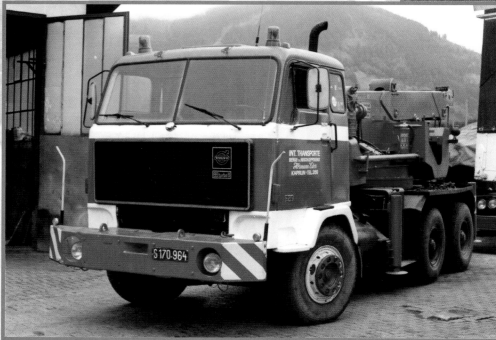

9.2 *Seen in Kaprun, Austria, this Volvo F89 has had some major alterations. With the headlights repositioned in a counterweighted bumper, it has a large rotating recovery crane on its chassis, and worked in the heavy haulage company of Eder.*

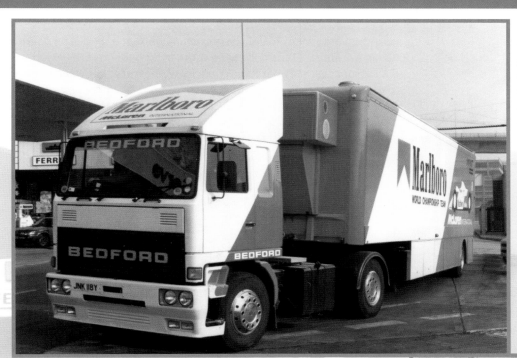

9.3 Now a user of top-of-the-range Mercedes Actros, the Mclaren Formula 1 team of the 80s used these brightly coloured Bedford TMs painted in the colours of sponsor Malboro, seen here after refuelling in Dover with a race car transporter. The modern team uses 15 trucks alone on the hospitality unit and another eight on the race team including the race car transporter, four curtain sided support trucks and one fridge truck for the food and drinks for the team and guests.

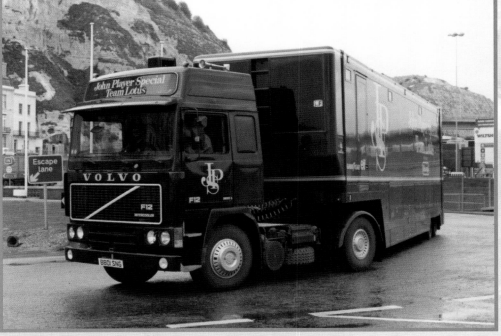

9.4 The Volvo F88 of the JPS Lotus Formula 1 team has featured before in publications, but seen here is the new kid on the block (or paddock if you like), an F12. The Team Lotus trucks of today are French registered Renault Magnums in Lotus Green, another imposing truck, but this F12 looks lovely in the old JPS colours as it leaves Dover Docks.

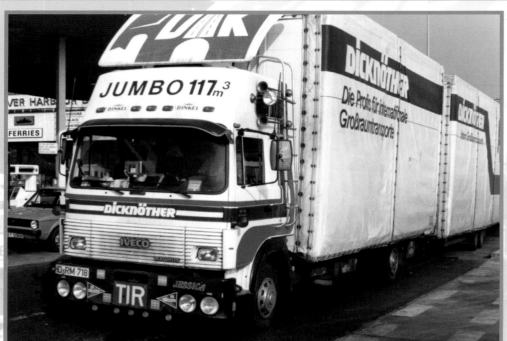

9.5 For loads that are lightweight, hauliers have had to come up with innovative ideas to get the maximum amount of goods on board within the limits set for height and width in Europe. This little Iveco 80.15 from Germany has huge capacity within its tilt body and that of its matching trailer, 117 cubic metres according to the sign writing on the spoiler. On top of the 'Club Of Four' sleeper cab is a neat high roof extension providing more interior room for the driver and any passenger carried, and entertainment is provided by a dashtop TV.

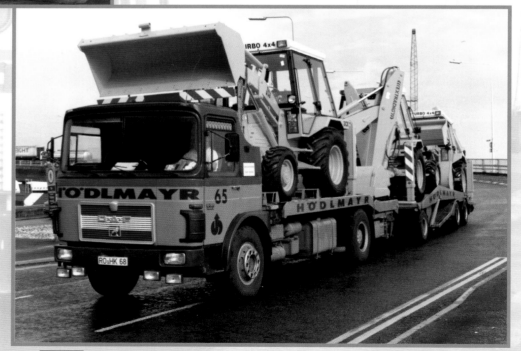

9.6 O.A.F. is a subsidiary of M.A.N. and specialise in the building of heavy duty multi-axle trucks, and purpose built special builds. This Bavarian registered 19.320 has a cut out section of the rear cab wall to enable machinery and vehicles to be loaded as close to the cab as possible, and is seen here with an export load of JCB 3CX machines from the factory at Uttoxeter.

9.7 *The quest for more load space led to some very strange outfits from the likes of DAF and Ginaf. This Belgian DAF 3300 possibly has a horizontal coach engine, but definitely has a set-back front axle and a second steer axle making it look quite unbalanced, especially with its drawbar trailer on low profile tyres.*

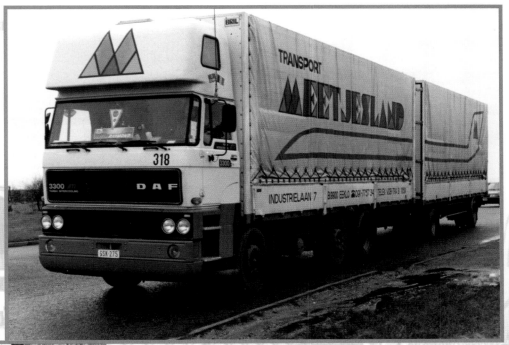

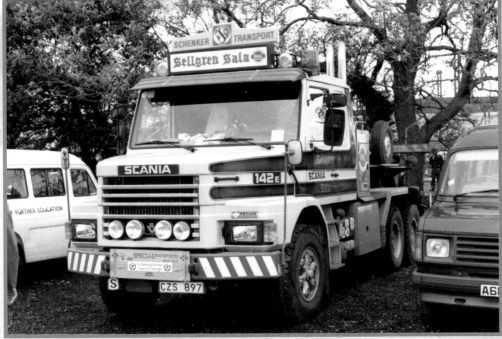

9.8 *A very rare sight in the UK was this Scania T142E all the way from Sweden. Seen at the NEC motor show, it probably towed an exhibit there, and is based normally at Sala, north west of Stockholm, and looks like it is contracted to the logistics giant Schenker according to the name board. Equipped with twin exhaust stacks and judging by the sticker it is also fitted with a Telma retarder.*

9.9 *A Ford Louisville belonging to Crouch's Garage of Ashford in Kent brings in an unfortunate Volvo of Fagg's Fleet. Crouch's were a Ford Trucks agent amongst others, and as it is being towed 'on the bar', let's hope it is only going to Ashford and hasn't travelled a great distance to reach this point, for the Volvo driver's sake alone.*

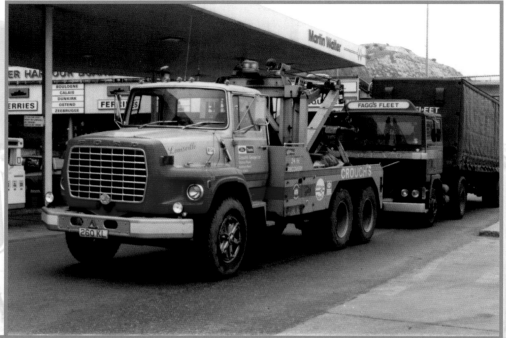

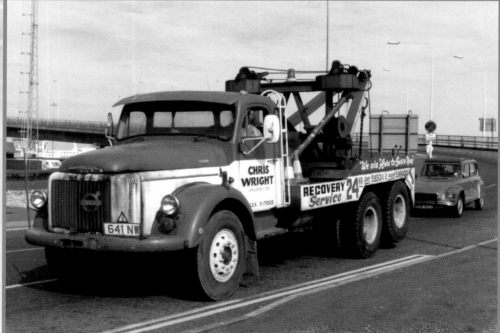

9.10 *'Tony's Tug' was a magnificent, but worn looking, Volvo N86, and looks here as if it has a Citroen 2CV in tow! Chris Wright (Baildon) was formed in 1976 with tippers, and then added flat vehicles, cranes and a low loader. Today it is still located at Baildon near Shipley, Yorkshire and runs a variety of low loaders, cranes, heavy haulage trucks and road planers as well as tippers and road sweepers.*

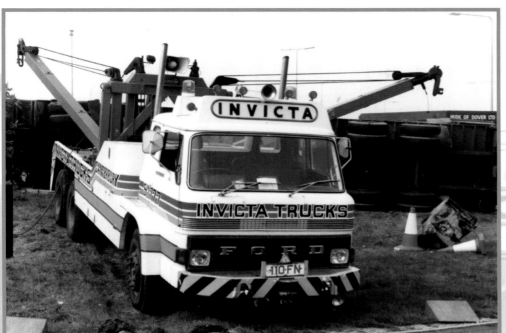

9.11 *A great picture of Invicta Trucks Ford D Series trying to right an Irish rig that had toppled over on the Whitfield roundabout on the A2 just outside of Dover. In the background can just be seen the canopy of the garage that was then being run by Husk of Dover, who were also involved in haulage and later opened a bunker garage further north on the A2 at Lydden.*

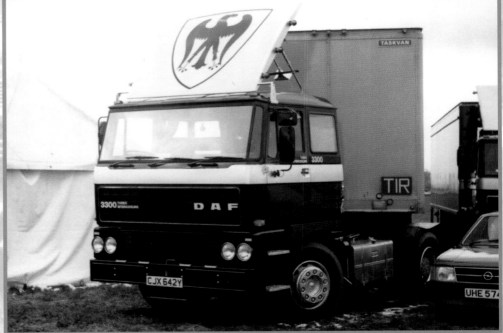

9.12 *In 1975, former nightclub owner D. Harvey Steinberg started out in the Rock and Roll trucking industry calling his company Stardes. Today the firm is still very much in existence and a major player in the industry, and the trucks all feature the logo that is the Steinberg family crest – the Prussian eagle, and still today it favours DAF as its choice of truck.*

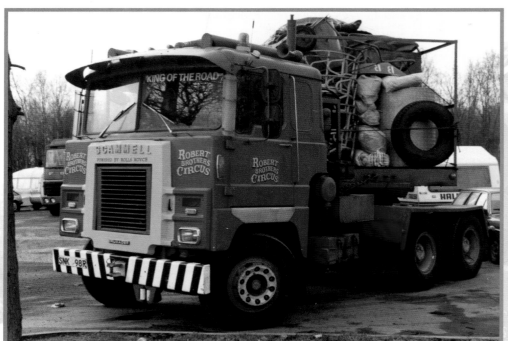

9.13 *Many British trucks have ended their working lives in the ownership of a circus, particularly if the truck has a reputation for power and durability, and it would be exactly these attributes that would have led Robert Brothers to purchase this Rolls Royce powered Scammell Crusader. As it is a double drive unit, it is possible that it started its working life in the armed forces as a tank transporter, or with a heavy haulage firm such as Pickfords or Wynns.*

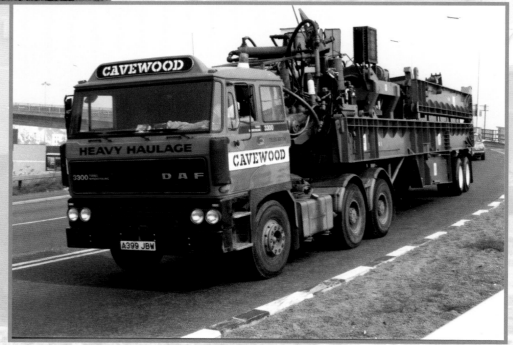

9.14 *Not the colours you normally associate with a Cavewood truck livery. This DAF 3300 is towing an unidentified piece of brand new equipment that is going to Dover for export, possibly a car crusher. It has its own running gear so just requires a tractor unit to move it around.*

9.15 *Taken in May 1984, driver Martin Palmer returns to Dover from Lyon to rest a few days before continuing on the UK leg of a Status Quo tour. The tour was called 'The End Of The Road Tour' as the band weren't going to tour after that, a promise that didn't last long! In fact, to date, Quo are one of the most prolific touring bands and spend almost all year on tour, every year! The Fiats were bought by Transam specifically for the Elton John European Express Tour of that year, and as they got them at such a knockdown price they bought some extra trucks, one of which was assigned to Martin. The ones put on the Elton John tour were given a superior paint job complete with Elton John logos, but Martin's was supplied as seen. Martin says the Fiats were 'hateful trucks', with about 310hp and Fuller 'crash' gearboxes and 'the drivers did their best to destroy them'! They were kept for around five years, not long for Rock and Roll trucks but the Fiats had started to fall apart. The 26ft trailers were bought from the BBC and were just as hated as the Fiats due to the lack of space and terrible manoeuvrability thanks to the axle being placed at the very rear of the trailer. Martin is looking pleased in this picture as he had just been released from the customs shed where the officers had insisted on the whole trailer being unloaded so they could see Quo's guitars that were right at the front! Also notice a fan has written in the dirt on the cab just in case Martin forgot who he was on tour with!*

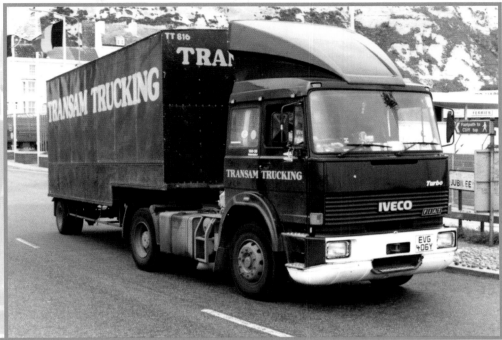

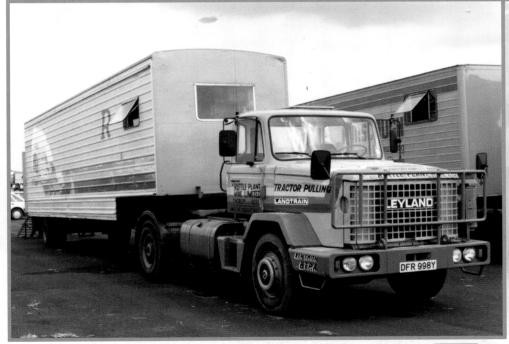

9.16 *Ruttle Plant Hire of Chorley ran a very mixed fleet of trucks including a fleet of Hino tippers, a Kenworth K100 and a Mack R700 cabover. Formed in 1958, it started out renting agricultural equipment to the farming community of north west England. It diversified into plant hire to the construction industry and now has additional depots in Lichfield, Preston, and Chesterfield in the UK, and has established bases in Canada, the U.S.A and the Sudan. This Leyland Landtrain was utilised to pull Ken Smith's tractor pulling trailer around to events. Ken was a service engineer for a forklift truck company and Ruttles provided the LHD Leyland to pull his 38ft van trailer containing his tractor and was equipped with living accommodation and workshop.*

9.17 Hugh Wilson needed a drawbar outfit to run at 4m in Europe. Initially runs were from the Case factory at Angers, France, to Poole in Dorset which was handled by a DAF 2800, but when asked to do inter factory runs to Germany and Holland, the DAF was found to be too high for the European height limit. Hugh went to see George Terberg at the factory at Benschop near Utrecht, Holland and in 1983 XIA 4382, a Terberg F975 6X2 rear lift was delivered with a running height of 700mm, achieved by tiny drive axle tyres that were 205/80 R15, never designed for drive axles!

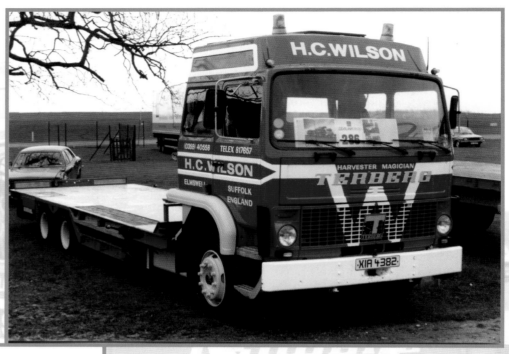

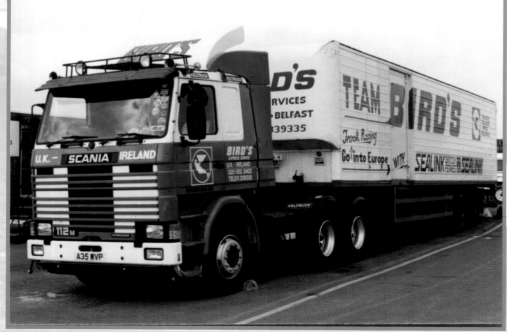

9.18 Andy Levett was a pioneering truck racer in the 80s, and his son Chris now races. To carry his race truck around, Andy used a truck from the family-run business Birds Groupage, along with a purpose-built race trailer. A Scania 112M is seen here at Brands Hatch with a support trailer attached.

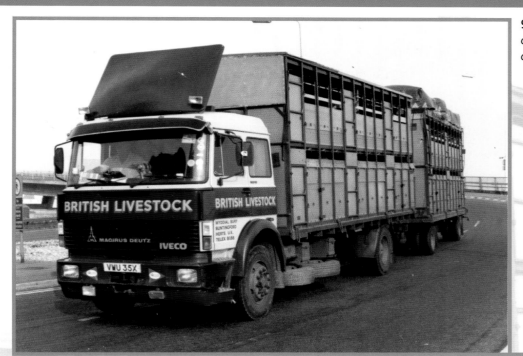

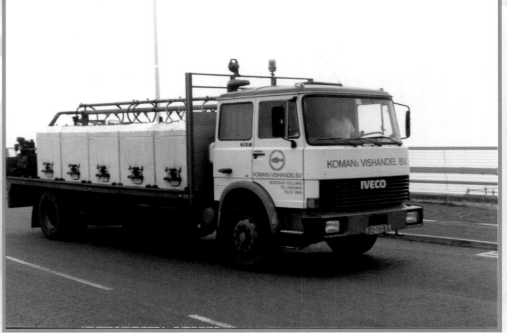

9.19 *A Magirus Deutz wagon and drag livestock transporter drops down into Dover. While the rigid carries the spare wheels the trailer is carrying the feed for the animals – on the roof!*

9.20 *Live fish transportation is a very precise business. The water is aerated by pipes leading from a compressor into the tanks of water. In this instance of a Dutch Iveco, the generator seems to be a very basic affair on the rear of the truck. The tanks are separated into several individual compartments not only allowing different types of fish to be carried in isolation, but also to help combat the surge of water when the vehicle brakes or accelerates.*

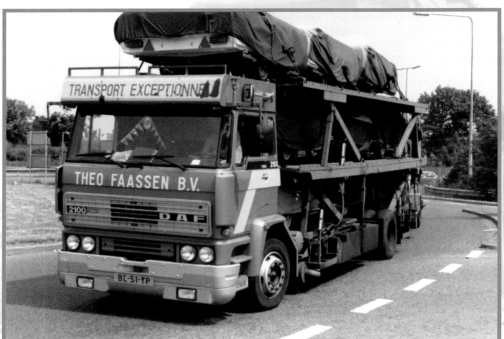

9.21 *This Dutch DAF 2100 has three decks which lift and lower by hydraulic ram, allowing the loading and unloading of leisure trailers. Looking at this outfit today it seems very strange to see unguarded and uncovered rear wheels, the truck only having spray flaps in front and behind the wheels.*

9.22 *A French Scania 92M with a full load of brand new Seat cars on board ready for delivery into the UK. French group Causse Walon took over the English firm of Abbey Hill from Yeovil, and had operations in eight European countries. In the UK it competed with the likes of Toleman and Silcock Express.*

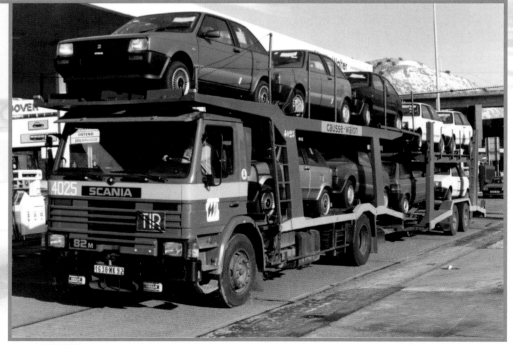

9.23 *A brace of French registered transporters, a Renault and a Saviem, exit Dover Port each carrying four tractors. The plates on the bumpers translate as transport under customs, presumably meaning although the loads are not covered and sealed they are customs inspected and travel under tight regulations.*

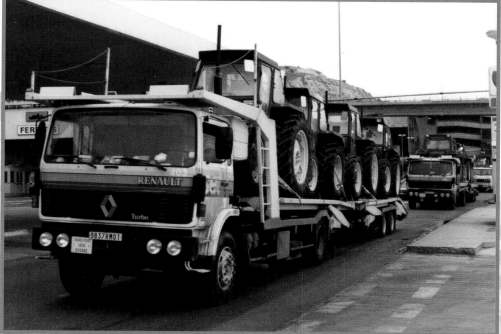

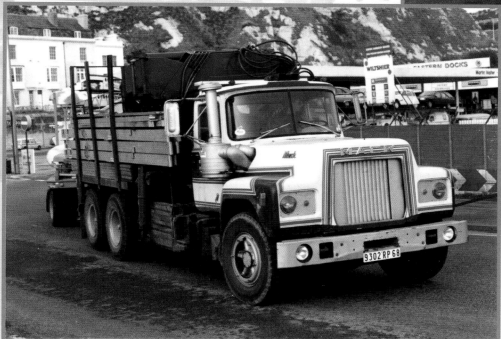

9.24 *A Mack R700 rigid and trailer from a French travelling fairground arrive in England. Equipped with a huge crane for unloading the rides, this truck was preceded by another Mack, this time an F700 cabover.*

BEYOND THE BOSPHORUS

DAVE BOWERS | HARDBACK | ISBN: 9781910456026

About the Book

In this book Dave Bowers tells with humour and insight the amazing stories of people driving to Middle East destinations, battling against all the odds to deliver their loads.

Illustrated with photographs of the drivers and vehicles taken at the time, Beyond the Bosphorus records what it was like for ordinary HGV drivers to get involved in something so dramatically different from their everyday working lives in the UK. It will be of interest to lorry drivers, general vehicle enthusiasts and also those with a historical and social interest in the Middle East alike.

About the Author

Dave Bowers has been writing features on trucks, the road haulage industry, travel, history, classic cars, tractors and repairing vehicles for a number of magazines, including Truck and Driver, Trucking, Heritage Commercials and Classic Truck for over 20 years.

DESTINATION DOHA

TONY SALMON | DVD PAL | ISBN: 9781906853143

About the DVD

Two "World About US" programmes broadcast in 1977 in which we meet truckers driving over 5,000 miles and 11 countries between Britain and the Arabian Gulf.

Doha, the capital of Qatar on the Arabian Gulf is 5,000 miles from London with 11 countries to travel through and 23 customs posts on the way. Blizzards in Austria, sandstorms in Syria: broken-down trucks to repair and bogged-down trucks to dig out of the sand.

This double DVD set contains both parts of the original programme. You'll see that for these Astran international drivers their work was more than just a job – it was a way of life with a series of adventure, winter and summer, ice-cold and desert-hot.

Running time is 98 minutes.

For our full range of products visit
www.oldpond.com or
call **0114 240 9930**
f /oldpond @oldpond

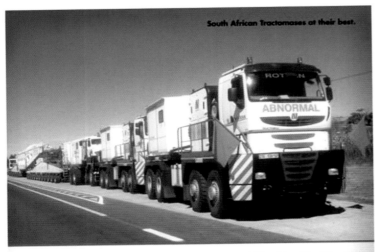

South African Tractomases at their best.

INTERNATIONAL HEAVY HAUL 2

Unipower and Faun working in harmony.

INTERNATIONAL HEAVY HAUL 2

74 MINUTES | DVD PAL | ISBN: 9781908397942

About the Book

In International Heavy Haul TWO we travel to four different parts of the world to bring you features showing heavy haulage at its most impressive.

The first film looks at the transport of two 130-tonne bridge beams in Australia. We see the crews starting their day's work in a remote layby on the Great Northern Highway between Perth and Port Hedland, and accompany them for some distance - excellent in- cab footage is included. Traction is provided by Mack-ballasted tractors with the beams supported front and rear on 7&8 row bogies.

In the second feature we move to South Africa. Here we were privileged to witness the movement of a 356-tonne transformer, which was being carried on a girder frame supported by 24 rows of axles. Motive power is provided by three 8x8 Tractomas ballasted tractors and a rebuilt 6x4 Pacific.

For our full range of products visit
www.oldpond.com or
call **0114 240 9930**
f /oldpond @oldpond

LORRIES OF ARABIA

ROBERT HACKFORD | PAPERBACK | ISBN: 9781908397935

About the Book

Published in 2015 this is an account of the magnificent ERF NGC machine hauling articulated road-trains over the Saudi mountains in Trans-Arabia livery. A treat for any Middle East trucking enthusiast.

This book is a tribute to ERF's world-class long-hauler, especially the Middle-East examples, and to those who drove them. What did the ERF NGCs look like? How well did they perform? Where did they venture? What were they like to drive and to live in? And where did they stand in ERF's contribution to Britain's place in the history of the TIR-trail?

About the Author

Robert Hackford is a retired teacher and long-haul trucker. He is author of Kamyonistan Quartet (a novel, Athena Press) and has had many articles published in trucking magazines.

For our full range of products visit
www.oldpond.com or
call **0114 240 9930**
f /oldpond @oldpond

WHERE'S SHARAWAH?

A TRUCK DRIVER'S ADVENTURE ACROSS THE ARABIAN DESERT

GORDON PIERCE | PAPERBACK | ISBN: 9781908397935

About the Book

This is the true story of Gordon Pearce, an English truck driver determined to get the job done. With the help of Bedouins he crossed three hundred kilometres of unpredictable desert in the height of summer 1978. Aside from the physical challenges, he has to battle bureaucracy and begins to dread hearing the word "bukkera" – "tomorrow".

Told in Gordon's ironic, modest style and illustrated with photos from that time, Where's Sharawrah? is a captivating book for vehicle enthusiasts and anyone who is passionate about truck adventures.

About the Author

Gordon Pearce started driving trucks in 1958, travelling frequently to the Middle East and all over Europe. He retired at the age of 72 in 2011 and lives in London.

For our full range of products visit
www.oldpond.com or
call **0114 240 9930**
f /oldpond @oldpond